HAUNTED
CRIPPLE CREEK AND TELLER COUNTY

HAUNTED CRIPPLE CREEK AND TELLER COUNTY

LINDA WOMMACK

Published by Haunted America
A Division of The History Press
Charleston, SC
www.historypress.com

Copyright © 2018 by Linda Wommack
All rights reserved

First published 2018

Manufactured in the United States

ISBN 9781467139601

Library of Congress Control Number: 2018936078

Notice: The information in this book is true and complete to the best of our knowledge. It is offered without guarantee on the part of the author or The History Press. The author and The History Press disclaim all liability in connection with the use of this book.

All rights reserved. No part of this book may be reproduced or transmitted in any form whatsoever without prior written permission from the publisher except in the case of brief quotations embodied in critical articles and reviews.

CONTENTS

Introduction	7
1. The Haunting of Gold Camp Road	11
2. Ghosts of the Cripple Creek Mining District	17
3. The Residual Echoing Effects of Phantom Canyon	74
4. The Haunting of Victor	79
5. Gold Mines, Ghosts, Goblins and Tommyknockers	94
6. Gold Camp Ghost Towns	100
7. More Ghost Tales of Teller County	112
8. Phantoms of Ute Pass	127
Bibliography	137
About the Author	141

Introduction

Legend and lore are often woven within the history of Colorado's past. Haunting history and ghost stories are particular examples. What better way to bring the two together than a recount of lively ghost stories in historic places? And what better place than the historic town of Cripple Creek, Colorado?

Cripple Creek is still the undisputed "Greatest Gold Camp on Earth." A middle-aged cowpoke with some mining experience discovered gold in the area that became Cripple Creek in 1891. His name was Robert "Bob" Miller Womack, my great-great-uncle. In the nineteenth century, more gold was taken out of the Cripple Creek Mining District than any other mining district in the world. As with all mining towns, Cripple Creek entered into a slow demise shortly after the turn of the century. Following Cripple Creek's near-death—for the town never did die—many of the old buildings sat empty for decades. The pioneer enterprising businessmen and -women, energetic lawyers, stockbrokers, mine owners and merchants became past history. Or did they?

During those idle years, Cripple Creek rebounded somewhat, and personalities abounded in the form of spectral apparitions. Folks would talk of seeing a ghostly figure in a window. Stories were whispered of doors slamming and objects moving when no one was in the room. The winter fog rolling off Mount Pisgah would often linger over the cemetery, lending an eerie presence to an otherwise peaceful repose for the dead.

Introduction

Cripple Creekers have come to accept this. As a matter of routine, as they swept the floor, cleaned a windowsill or dusted a shelf, they would glance over their shoulders as if to assure themselves that they were indeed alone. Or were these anomalies actually visitors from the past?

I have always been curious about the possibility of supernatural occurrences. When I finally experienced what I believe were encounters of an eerie nature, ironically enough in Cripple Creek, I was no longer a skeptic, nor was I completely convinced. But I began exploring the possibility.

It began with all the interviews, visits and correspondence I underwent while researching my cemetery book, *From the Grave*. I would constantly be told of ghost stories and hauntings, particularly in Cripple Creek and Teller County. As I am the great-great-niece of Bob Womack, the man who discovered gold at Cripple Creek, this piqued my interest. I soon learned that Cripple Creek is believed by many in the know to be the most haunted city in the state.

As a historian, I naturally based my research on the history of the various buildings, places and structures that are said to be haunted. This often led to the who, what and why of a particular haunting. Because of their very nature, the few surrounding ghost towns and their poltergeist history were also included in this research.

Following the end of the mining era, many of the old buildings sat empty for decades. The ghosts of Cripple Creek and Teller County seem to still roam the area. When legalized gambling once again became a reality in October 1991, exactly one hundred years to the month of Bob Womack's gold discovery, the haunting stories seemed to gain a whole new audience.

To this day, over a century after Womack discovered gold, and though Cripple Creek is now more commercial than ever, there are still stories of unexplained footsteps, doors slamming and other mysterious occurrences in the Cripple Creek area.

"I'm inclined to think we are all ghosts—everyone of us. It is not just what we inherit from our mothers and fathers that haunts us. It is all kinds of old defunct theories, all sorts of old defunct beliefs, and things like that." So wrote Henrik Ibsen in his 1881 book titled *Ghosts*. I suppose there is some sort of symmetry to such a notion. But I prefer to take a lighthearted attitude toward the paranormal phenomena of ghosts and hauntings.

Cripple Creek and Teller County have an unbelievable history of ghoulies, ghosts, goblins, long-leggedy beasties and things that go bump in the night. Friend and fellow writer Joanne Sundell wrote, "Show me

Introduction

someone who doesn't love a ghost story and I'll show you someone who has no imagination."

Science, paranormal investigators and physics cannot explain the realms of the hereafter or provide a logical explanation of ethereal beings. But history and storytelling can bring a certain symmetry to the possible existence of a third dimension. And we must not discount the advancements in audio recordings, digital photography and electronic devices often used when encountering the unknown spirit world.

Many examples of paranormal investigations come from members of various ghost-hunting groups, as well as Michelle Rozell, director of the Outlaw and Lawman Jail Museum. Michelle was also instrumental in procuring many of the photographs that are included in this work; I am very grateful to her for her contributions. I would also like to thank Richard Termayne, director of the Cripple Creek District Museum, for allowing me full access to the amazing photo collection at the museum.

This is a collection of the history of the hauntings of Cripple Creek and Teller County.

CHAPTER 1
THE HAUNTING OF GOLD CAMP ROAD

Cripple Creek, somewhat secluded, is accessible by a few different routes. From Divide, Highway 67 south follows the old Midland Terminal Railroad into Cripple Creek. County Road 1 from Florissant takes the traveler into Cripple Creek. Likewise, County Road 4, known as the Gold Camp Road, runs into the town. This was originally a stage road and the roadbed for the Short Line Railroad.

From Old Colorado City, now a suburb of Colorado Springs, Gold Camp Road begins at Twenty-First Street. Located high in the rocky hills of Bear Creek Park is a series of three tunnels of the Gold Camp Road that some say are so haunted that many travelers would rather turn around than continue the journey. Five years after competing railroads, the Midland Terminal and the Florence & Cripple Creek, arrived in the gold mining camp, a third rail bed was being built from Colorado Springs to Cripple Creek. It was the Colorado Springs & Cripple Creek District Railroad, better known as the "Short Line." The narrow-gauge line was financed by a group of Cripple Creek mine owners who believed a shorter route to the gold camp would bring more people, business and profit. To achieve that goal, the rails were built with switchbacks to gain the elevation of three separate levels. Portions of the rail bed were built right along the mountainsides and canyon walls. It snaked around the south side of Pikes Peak to reach Cripple Creek in less time than the competition.

To shorten the route, nine tunnels were built through the granite rock. When completed, it was considered an engineering marvel. It came at a

hefty cost to the mine owners of over $4 million. The Short Line Railroad was forty-six miles in length, nine miles shorter than its competitors. Advertisements boasted two trips daily in and out of Cripple Creek. To achieve this, the company purchased eight eighty-five-ton locomotives and four switch engines. Added equipment included eighteen passenger cars, four observation cars, two hundred boxcars and sixty ore cars.

From the first train arrival in Cripple Creek on April 8, 1901, the Short Line outdid its competitors. Then the companies launched a price war. Each time the Midland Terminal Railroad lowered its ticket price, the Short Line matched it. Later that year, when Vice President Theodore Roosevelt rode the Short Line into Cripple Creek, he exclaimed, "This is the ride that bankrupts the English language." This was the best advertising of all, as the following summer over fifty thousand tourists rode the train. It is interesting to note that the "Short Line Railroad" on the Monopoly game board is named for this Colorado railway.

Despite all the great advertising and public accolades, the Short Line only operated for four years. In 1905, the rail line was sold in an effort to keep the company and its investors from bankruptcy. The new owners, the Colorado & Southern Railroad Company, then leased the Short Line to the Midland Terminal Railroad Company. Following World War I, the mines in the region were not as productive and the economics of running a railroad were no longer profitable. In 1920, the Short Line ceased operations.

In 1926, W.D. Corley, a Colorado Springs coal operator, secured the former railroad company's right-of-way and opened the Corley Mountain Highway. In 1939, the former railroad bed officially became the Gold Camp Road. Managed by the U.S. Forest Service in 1940, the road was improved through a Works Progress Administration (WPA) grant. Today, three of the original tunnels remain.

The length of the tunnels varies from 170 feet to over 500 feet. Tunnel #1 was bored straight through the granite and needed no side timbering inside. The other two tunnels were not as easy, and many workers lost their lives in explosions and rock fallings. One such worker is reportedly still in the tunnel. He is often seen by travelers wearing brown clothing, tall work boots and a miner's helmet and carrying a lantern.

Tunnel #2 is 180 feet long. There have been reports of orbs and light streaks during both day and night trips. Travelers report strange shadows and apparitions appearing in their vehicles' headlights.

Today, a favorite game for young teenagers is to drive through the tunnels at night. They often stop in the middle of the tunnel and explore, looking for ghosts. While the car headlights make for strange shadows, the young kids usually scare themselves silly rather than the supposed ghosts doing that for them.

Tunnel #3 is said to be the most haunted. The story goes that in the mid-1970s, a group of schoolchildren was returning from a field trip in Colorado Springs when the school bus was trapped by a partial cave-in. Several children died, as did a teacher and the bus driver. However, there is no record of such a horrific accident. Further, the gravel-based tunnel has always been extremely loose. Several repairs were done to prevent a cave-in, including partially timbering both ends of the 207-foot-long tunnel. However, in 1988, another portion of the tunnel caved in. Although it was only a partial cave-in, Teller County officials chose to close the tunnel rather than repair it. Nevertheless, to this day, people

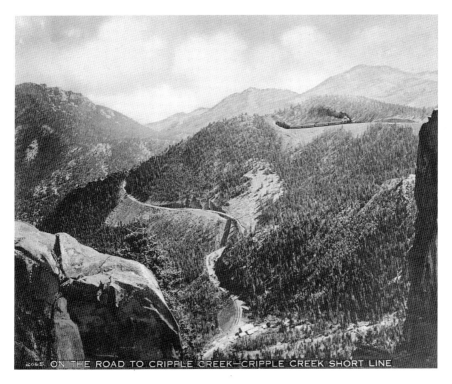

The famous Short Line Railroad on what would become the Gold Camp Road. *Denver Public Library (DPL).*

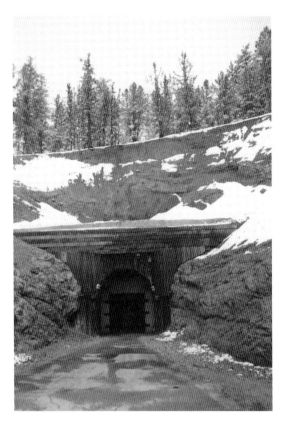

Left: Tunnel #2. *Author's collection.*

Below: Tunnel #3, now closed due to a cave-in—or ghosts? *Author's collection.*

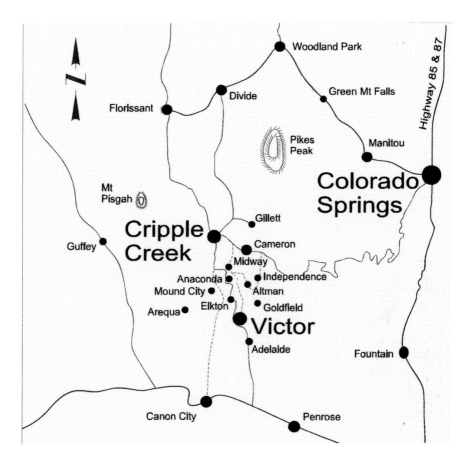

Map. *Paul Marquez.*

believe the school bus story happened. The same light sensations as in Tunnel #2 are said to occur, and prior to the closure, many travelers reported seeing the apparition of a miner carrying a lantern. Others have said they heard wailing sounds, possibly the ghosts of the children on the bus. Peter Garrett related the following story: "At the end of the tunnel, three little girls appeared. They slowly walked toward our car and then disappeared. When we came out of the tunnel, we noticed little handprints on the sides of our car."

Visitors approaching the closed tunnel on foot have claimed to see dried blood splatters on the rocks and have heard children giggling from the blackened hole of the tunnel entrance. After gazing into the tunnel through the wrought-iron fence, people have noticed small handprints and fingerprints on their vehicles. Nearby the closed tunnel, in a deep ravine,

is an old rusted vehicle. The story, as related to me, is that the vehicle ran off the road sometime in the 1980s, and all inside were killed. It is said the ghosts of the vehicle accident now haunt the area.

In the spring of 2006, a mysterious fire raged throughout the tunnel. The authorities suspected arson but never fully investigated the matter. Poltergeist phobia?

Chapter 2

Ghosts of the Cripple Creek Mining District

Almost from the beginning, I knew something wasn't right. The dogs growled at something or someone we didn't see. But I wasn't frightened—at first.
—Charles Frizzell

On the south side of Pikes Peak lies the small mountain town of Cripple Creek. After Bob Womack discovered gold here in 1891, Cripple Creek soon became the "Greatest Gold Camp on Earth." As with any mountain mining town, Cripple Creek had its share of crime and lawlessness. It is said that at one point in its history, Cripple Creek boasted an average of one murder per day. The mining town also experienced disasters in the form of mining accidents, fire, labor strikes and violent and bloody conflicts between union leaders.

With so much disconcerting energy, it is not surprising that there is an unseen population roaming throughout the town. Therefore, it is little wonder that many believe Cripple Creek is the most haunted mountain mining town in Colorado.

"The Ghosts of Cripple Creek"
The ghosts of Cripple Creek walk quietly
And unobserved, save where our knowing eyes remember,
Save where we recognize the restless shadow forms.
Walk along Bennett with its tilting walks
And ghoul-eyed windows.

*Feel the forms push you as they crowd forsaken streets
To walk their restless pace…a pace born of a fever
That cannot be quenched by death.
Loiter at Sixth and see if you can outline Womack
As he throws away his money to the crowd…
Ill-fated Bob, forgotten and as lonely
As the wind that cuts him through.
Watch the hawk soar upon the hill
Where white horse rides straight into fog.
Watch Stratton dream before the Palace fire
No longer puzzled by the weight of Gold.
The ghosts walk quietly in Cripple Creek
And unobserved, except where knowing eyes
Remember and re-live.
—Hunt and Draper*

The Cripple Creek Fires

Just three years after Bob Womack discovered gold in the Cripple Creek region, the 1894 *Cripple Creek Business Directory* listed nearly eight hundred businesses in the thriving mining town. With such prosperity, city officials began making improvements to the growing community. Two reservoirs were completed. Miles of underground pipe had been laid from these reservoirs to the city's main lines. This not only provided water for the town but also would provide the needed water should there ever be a fire. Water hydrants were installed, and a six-hundred-pound fire bell was purchased. A group of men formed as volunteer firefighters. Unfortunately, all the preparations put in place by the Cripple Creek fire department could not save the town from the worst fire disaster in its history.

At noon on Saturday, April 25, 1896, fire broke out on Myers Avenue and moved, slowly at first, from building to building. Earlier that morning, a young couple staying in an upper room of the Central Dance Hall, located on Myers Avenue, had begun to argue. As their argument became physical, the woman, Jennie LaRue, was knocked backward, turning over a gas stove. The spilled flammable liquid spread across the floor, engulfing everything in its path. Within minutes, the wood-framed structure of the Central Dance Hall was ablaze. Very quickly, the fire spread to the next building.

As the winds from the south began to pick up, sparks from the burning buildings jumped to the buildings on the north side of Myers Avenue. In an effort to minimize the spread of the fire and create firebreaks where possible, Police Chief James M. Marshall ordered several buildings along Myers and Bennett Avenues to be blown up. Using dynamite, buildings at the corners of Myers and Third Street were leveled, to no avail, as the fire moved north to Bennett Avenue. Pandemonium soon broke out on the commercial street of Cripple Creek. Businessmen loaded what they could into wagons and fled the area.

By that time, the firemen and hose team were able to use the high masonry wall, which divided the upper and lower sides of Bennett Avenue between Third and Fourth Streets, as a natural barrier for defense. The men used this barrier by placing the hoses on top and in front of the wall in an effort to stop the fire from crossing Bennett Avenue. Unfortunately, due to the intense heat and thick smoke, the firemen were forced to retreat. The fire rapidly jumped to the north side of the street. Every building quickly caught on fire. Police Chief Marshall, realizing the fire would soon engulf the new city hall building, ordered the release of the prisoners from the locked jail.

Early Cripple Creek at the time of incorporation, 1892. *DPL.*

Robert "Bob" Womack discovered gold in 1891. *DPL*.

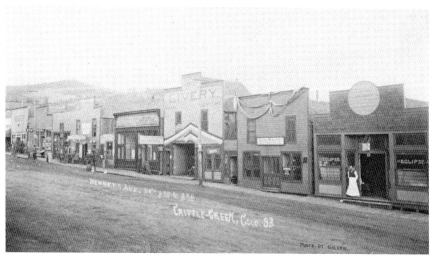

By 1893, false-front wooden buildings lined both sides of Bennett Avenue. *Pioneer Museum (PM), Colorado Springs*.

Myers Avenue had its share of businesses as well. *DPL.*

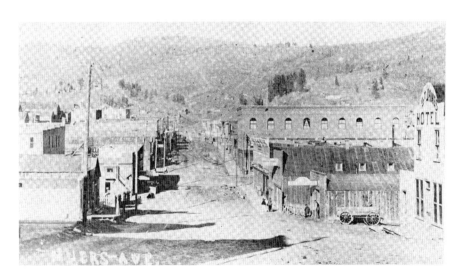

The red-light district of Myers Avenue. Could the wooden building on the right be Pearl DeVere's first Old Homestead brothel? *Fred Mazzulla collection, Amos Carter Museum.*

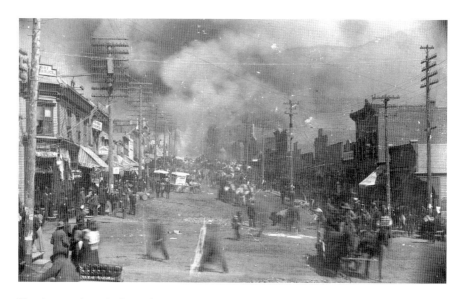

Fire destroyed nearly the entire town in April 1896. *DPL.*

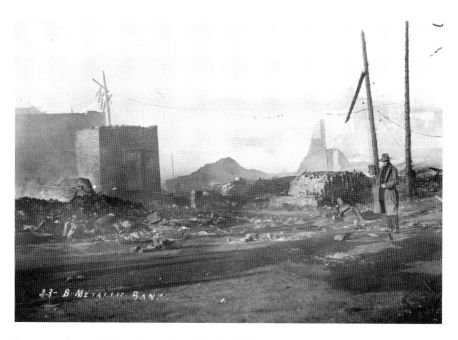

Surveying the smoldering aftermath of the fire. *DPL.*

As the sun began to set on that frightening day, the winds began to subside, allowing the firefighters to finally gain the upper hand. However, it was well after midnight before the firemen's hoses doused the last of the glowing embers of fire.

Early on Sunday morning, town officials, policemen and firemen were assessing the damage to the town. Amazingly, several business owners were already busy rebuilding their establishments. By Wednesday many businesses had reopened, including the First National Bank and the *Cripple Creek Morning Times*, which never missed an issue. A sense of normalcy seemed to return. That is, until approximately 1:30 p.m. on April 29, when the sound of the fire bell rang out. Fire broke out at the Portland Hotel, on the northeast corner of Second Street and Myers Avenue. A hotel waitress, Bessie Kelly, discovered the fire racing up the grease-soaked walls of the kitchen. When the firemen arrived, the entire building was consumed in flames. The firemen used their hoses, sending a steady stream of water on the burning hotel, as well as the alley, but to no avail. The fire jumped north, across Myers Avenue, toward Bennett Avenue. The flaming embers landed on the roof of the Wright Hardware store, where the ammunition stocked in the store exploded.

By late afternoon, the winds were so fierce that they only intensified the fire danger. Every building on Bennett Avenue west to the intersection with Third Street fell victim to the fire's intensity. The south winds helped move the fire to the north end of town, the residential area. As the fire threatened homes on Carr and Eaton Streets, residents were forced to evacuate.

By 4:30 p.m., the Cripple Creek firemen had the fire under control. The early sunrise the following morning was hazy due to smoldering debris all over the town. Only three days after the first fire, Cripple Creek was indeed crippled.

Six people died in the fires, and several more were injured. Over five thousand citizens were homeless. The value of property lost in the fires was estimated at over $2 million.

Because the entire town of Cripple Creek is a National Historic District, there are many century-old buildings lining both sides of the town's main street, Bennett Avenue. This commercial street is quite unique, as it was laid out on a hill. Thus, one side of the street is higher than the other. With so many ghost stories involving nearly all of the storied structures, it's impossible to say which is the most haunted.

At the upper end of Bennett Avenue is the Cripple Creek District Museum complex. The Colorado Trading and Transfer Building is historic for a few reasons. Not only was it one of the first buildings erected in the new mining town called Cripple Creek, but it is also the only wooden structure on Bennett Avenue to have survived both fires in April 1896. It is also said to be haunted.

In 1890, Albert A. Carlton and his brother Leslie arrived in the Cripple Creek Mining District from Colorado Springs. The two brothers wasted no time in starting a delivery service of coal and firewood to businesses and homes that could afford the convenience. The business did so well that in 1894, the Carlton brothers purchased a commercial town lot at the upper end of Bennett Avenue to expand their enterprise. John H. Eisenhart was hired to construct a two-story wooden building where the Carlton brothers established their Colorado Trading and Transfer Company. This was one of the first such companies to provide freighting services from the district to the nearest railroad depot at Hayden Divide. A.A. Carlton would go on to be one of Cripple Creek's wealthiest businessmen and ended up being the mountain mining town's last industrial tycoon. In 1899, the Carltons sold the building to the Midland Terminal Railroad for the purpose of its freight depot.

Today, the Colorado Trading and Transfer Building is part of the Cripple Creek District Museum. There are several ghostly tales, one of which the author has experienced. Over the years, during various routine maintenance projects or renovations, folks tell of strange markings and stains on the walls that bleed through every time there is a fresh coat of paint applied. It is also said that there are cold spots in several areas of the building. During one of many visits to the museum over the years, I experienced this firsthand. My mother and I were taking a quick tour of the museum grounds after having spent several hours doing research in an upstairs room in the depot building of the museum. While we were inside the Colorado Trading and Transfer Building, I walked toward a bookshelf that held several extremely old books. Just as I knelt to read the volume titles, I instantly became chilled. I looked around for some sort of explanation. After a few moments, I left the area and walked back to where my mother was chatting with an elderly woman. While the incident seemed rather odd, I quickly dismissed it. Years later, in 2013, during another visit with friends, we entered the building. At this time, the building housed the museum gift shop. While perusing the many items, one of my friends and I turned a corner and instantly felt chilled. We looked at each other in silence and then quickly walked away.

On July 2, 2011, members of the Mountain Peak Paranormal Investigations group spent part of the day inside the old Colorado Trading and Transfer Building. While their equipment and cameras did not capture anything unusual, one of the members, Frank, did witness an unexplained happening. Frank later reported that while in the gift shop, he witnessed a book fly off a shelf that no one was near.

AT THE EDGE OF a hill at the east end of Bennett Avenue, Cripple Creek's commercial street named for town developer Horace Bennett, is the imposing Cripple Creek District Museum. This was the most important building in town when it was erected in 1896 as the Midland Terminal Depot. As such, there was much human activity on a daily basis. Apparently, there is quite a bit of paranormal activity as well, because this building is said to be home to a number of ghosts.

By 1894, the owners of the Cripple Creek District mines—over 150 by that time—were losing profits to the high transportation costs incurred when shipping their ore to smelters. W.S. Stratton, Cripple Creek's first millionaire, and Harry E. Collbran, general manager of the Colorado Midland Railroad depot at Hayden Divide, all agreed that a railroad was needed to serve the Cripple Creek Mining District. When Collbran's superiors rejected the idea, Collbran, determined to build a rail line into the gold mining district, sought financial backing. Stratton steered Collbran to another acquaintance of his, Colorado Springs millionaire Harlan P. Lillibridge. With a $100,000 loan from Lillibridge, Collbran formed his own company, which he named the Midland Terminal Railroad. However, Collbran's railroad crew had only laid nine miles of narrow-gauge track from Hayden Divide before Collbran ran out of the needed funds to continue.

Collbran managed to secure additional funds and a new partner, W.G. Gillett, a fellow employee and company auditor with the railroad company. Rails were laid from the Colorado Midland Depot at Hayden Divide southwest to the gold mining district. For whatever reason, perhaps in an effort to gain an advantage over the competition, Collbran chose to switch from his original plan of narrow-gauge rails to standard-gauge rails. Therefore, the entire nine miles of previously laid track were rebuilt.

Albert A. Carlton and his brother Leslie, owners of the Colorado Trading and Transfer Company, located at the east end of Bennett Avenue, believed that a second railroad serving their town would benefit both the citizens as well as commerce. Therefore, the two men offered Collbran the lot adjacent

to their business for the railroad's depot location. In return, the Carlton brothers asked for exclusive rights to deliver freight and ore to the railroad. Collbran agreed to the business proposition. However, because a depot was already under construction at Gillett, named for Collbran's partner, the idea of a new depot was put on hold.

Finally, in December 1895, the standard-gauge Midland Terminal Railroad arrived in the Cripple Creek Mining District. Passengers paid two dollars for a round-trip ticket. The rail yards for the Midland Terminal Railroad were headquartered at Bull Hill, near the summit of Victor Pass, an elevation of ten thousand feet.

The Carlton brothers were soon proven to be correct in their assessment of competition. The Midland Terminal Railroad reaped huge profits from the transportation of freight and gold ore from the Cripple Creek area, thanks to the services of the Carlton brothers.

In the spring of 1896, Collbran began building the new railroad depot proposed by the Carlton brothers. Located just east of the Carltons' business structure, the new Midland Terminal Depot was a three-story brick building, with one portion of the structure built lower due to the uneven land. Inside, the main floor was used for loading and unloading freight. Passengers entered through a separate doorway and made their way up the massive staircase to the second floor, where tickets were purchased. Two waiting rooms were provided for both passengers and folks waiting to greet arrivals. One room was for gentlemen only, and the other was for women and children. The third floor contained private offices for railroad personnel. From the time the new depot opened in the summer of 1896, it became the focal point for Cripple Creek activity. Collbran ran four trains daily throughout the Cripple Creek Mining District. Passenger trains arrived and departed three times a day: at 3:30 p.m., 8:30 p.m. and 11:30 p.m. An additional passenger car was available at 2:40 a.m. Pullman service was also available on selected trains.

Cripple Creek's citizens would often stop by the Midland Terminal Depot to pass the time of day, enjoy the arrival and departures of the train and watch the comings and goings of the passengers. For the next fifty-five years, the Midland Terminal Railroad Depot served passengers arriving and departing the mountain mining town. Over the years, the railroad was owned by several different companies. Thus, the depot building operated under different names as well. After the Midland Terminal merged with the Colorado Springs and Cripple Creek Railway, the building was known as the Union Depot. Later, when these two rail companies merged with the

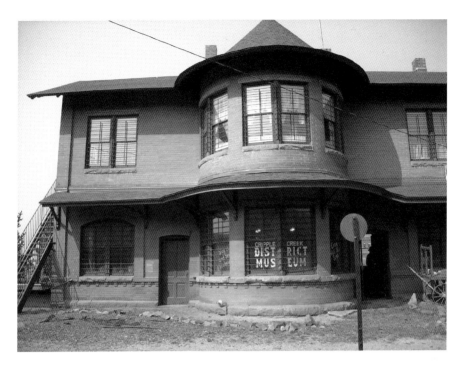

The Midland Railroad Depot is now the Cripple Creek District Museum. *Author photo.*

Florence & Cripple Creek Railroad, the depot was renamed the Cripple Creek Central Depot.

The last train to leave the depot was on February 6, 1949. The building sat vacant until 1953, when Cripple Creek citizens Blevins Davis, Margaret Giddings and Richard Johnson acquired the historic structure for the purpose of opening a museum. On Flag Day, June 14, 1953, the Cripple Creek District Museum was open to the public.

With so much activity throughout the years, it is no surprise that there are also reports of paranormal activity. Staff members as well as visitors have reported seeing a little girl, age five or six, in a white dress playing on the third floor of the museum. Erik Swanson once told me of smelling cigar smoke when he was on the upper floors of the building during his tenure as museum director. Kathy Reynolds, one-time museum curator, told me she knew of the ghost stories but had not experienced any poltergeist activity. Another museum director, Richard Tremayne, told me of an incident when a recorder was left in the living quarters. When retrieved, it had a recording of a little girl reciting church hymns.

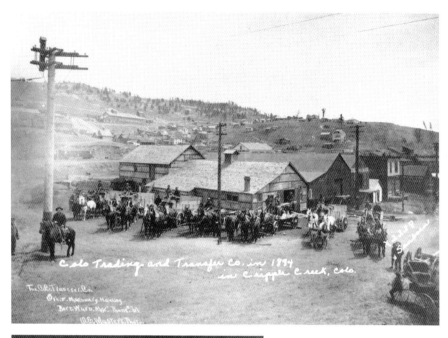

Above: A.E. Carlton's Trading Company dominated the early freighting business. *DPL*.

Left: Albert E. Carlton would go on to be one of Cripple Creek's most influential businessmen. *DPL*.

Over the years, members of the Mountain Peak Paranormal Investigations group have investigated various rooms of the building. During one such session in 2009, the electronic voice phenomena, or EVP, equipment recorded the voice of a young child, although the words were indistinguishable. On another investigative mission the following year, two members were alone in one of the rooms when a music box on the fireplace mantel began to play. Quickly, the two set up the EVP equipment. When the music stopped, the investigators took pictures of the room, including the music box on the mantel. Later, when they played the EVP for the museum staff, they were told there is only one music box in the museum and it was not located in the room the investigators were in. Further, they were told that the song that they recorded was not the song that plays on the music box. When the group returned to the room, sure enough, there was no music box on the mantel. Even stranger, when the investigators developed their film, there was no music box in the picture.

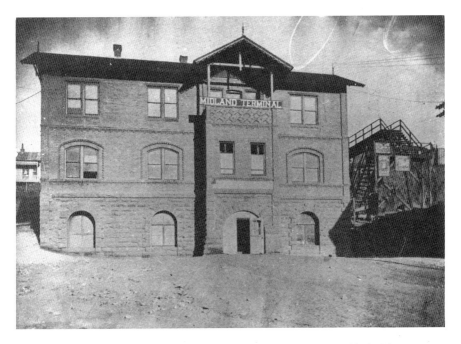

The Midland Terminal Railroad Depot was built in 1896. *Cripple Creek District Museum (CCDM).*

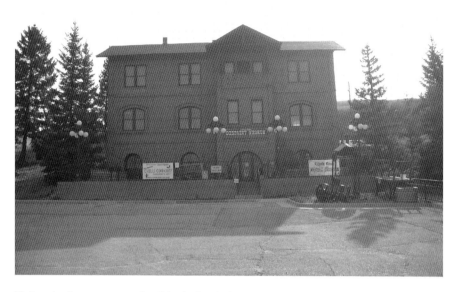

Today, the depot serves as the Cripple Creek District Museum and is said to be quite haunted. *Author photo.*

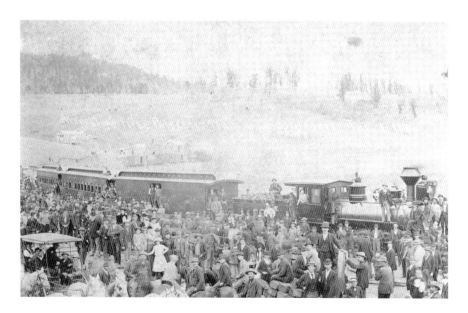

Citizens of Cripple Creek gather for the arrival of the first train into the district. *DPL.*

Inside the walls of the historic Gold Mining Stock Exchange Building (373–79 Bennett Avenue), an array of paranormal activity has been reported, from flying objects to noises, voices and colorful dancing orbs.

In 1892, Cripple Creek city officials had the foresight to approve the erection of seven telegraph poles in and near the city. Later that year, this proved to be quite useful for Cripple Creek's first stock exchange, the Cripple Creek Stock Board and Mining Exchange. A large two-story wooden building was constructed at 379 Bennett Avenue. While private offices occupied the second floor, the real action was on the first floor. Mine owners and businessmen came in several times a day to learn the latest on their various stocks, as well as buy and sell. These transactions were wired throughout the day to Colorado Springs, Pueblo and Denver, where they were sent on to the New York Stock Exchange. Business was so brisk that a several mine owners organized their own group in 1895 and took over the stock exchange. The Gold Mining Stock Exchange Association included some of the wealthiest and most influential men in the Cripple Creek Mining District, including Winfield Scott Stratton, Spencer Penrose, Charles L. Tutt, Albert E. Carlton and Verner Z. Reed.

In April 1896, this exchange building burned to the ground along with nearly all the buildings on Bennett Avenue. Within days, construction of an elaborate three-story corbelled brick and natural sandstone building began. When it was completed in December 1896, it was the largest structure in town. Built on two twenty-foot-wide commercial lots, the building had a depth of over one hundred feet. The three-story height was forty-eight feet. The back half of the main floor contained an open room, known as the stock exchange's "call" room, complete with bench seats for spectators. The front end of the main floor was leased retail space. Some leaseholders contributed to the storied past of this building.

In 1900, G.R. Lewis leased the southeast corner space and opened a pharmacy, G.R. Lewis & Company. It was only a matter of time before the pharmacist began dabbling in the stock trading being offered in the same building. One of the first blocks of stock Lewis purchased was in W.S. Stratton's Independence Mine. The returns on that stock alone made Lewis a very wealthy man. Lewis later became an influential board member of the First National Bank under A.E. Carlton's ownership.

Also in 1900, the southwest corner space of the building was leased to J. Grant Crumley, who established his Newport Saloon. Due to Crumley's reputation of underhanded mining activities, including high-grading, his saloon seemed to attract like-minded individuals. In September 1901, one

Left: Winfield Scott Sratton was the first millionaire due to Cripple Creek's gold. Stratton was influential in bringing the railroad to the mining district. *DPL*.

Right: Spencer Penrose was not only a wealthy mine owner, but he also built the influential Bi-Metallic Bank Building. Today, that building plays host to poltergeists. *DPL*.

of the saloon's patrons, mine owner Sam Strong, was killed by a shotgun blast to the head by saloon owner Crumley.

For several years, the Elks Lodge, Benevolent and Protective Order of Elks #316, had occupied the third floor of the Fairley & Lampman Building. In 1911, A.E. Carlton lent the group the money to purchase the building. The new occupants installed locks on the double-door entrance that remained locked all day. Entry was gained by using the buzzer and being let in by an approving lodge member. A large taxidermied elk dominated the first-floor lobby. The Grand Lodge meeting room was in the back, formerly the stock exchange "call room." The upper rooms were used for offices and meeting rooms.

Over one hundred years later, the Elks remain in the building, as does the stuffed elk. In August 2011, members of the Mountain Peak Paranormal Investigations group explored several rooms in the building. They reported several orbs in the main meeting room, as well as flying objects in another. However, the room with the most paranormal activity was the southwest corner of the first floor, the former Newport Saloon,

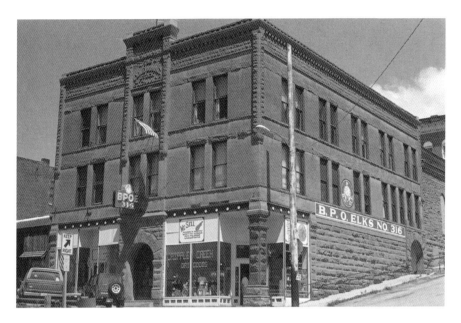

Built shortly after the 1896 fires, the BPO Elks building still stands. *DPL.*

where the killing of Sam Strong occurred. The group reported seeing objects in the room, yet when the camera film was later developed, the objects were not there.

AT THE SOUTHWEST CORNER of Bennett Avenue and Third Street is Johnny Nolon's Saloon & Gambling Emporium. This is the oldest drinking establishment in Cripple Creek, and the locals say it is haunted.

Johnny Nolon had ventured west from St. Louis, Missouri, following the gold discoveries in Colorado Territory. Arriving in Cripple Creek in 1890, Nolon established one of the first saloons in the new mining town. Unfortunately, his establishment was destroyed in the devastating 1896 fires. Shortly thereafter, Nolon went into partnership with Jacob Becker. The two commissioned the construction of the new Becker & Nolon Block. Located on the same corner lot, the two-story brick building contained businesses on both floors. Nolon's Saloon & Gambling Emporium occupied one half of the main floor, and the Cripple Creek State Bank operated out of the other half. Nolon also had an office on the second floor where he ran a liquor business and managed his many mining stock purchases. Nolon and his family moved to Nevada in 1903. Jacob Becker took over the partnership, operating it for several more

years. With legalized gambling in 1991, Johnny Nolon's Saloon & Gambling Emporium once again began operating one hundred years later.

Strange as it seems, given the nature of the original business and the casino operation of today, children roam the halls of Johnny Nolon's. Little boys have been seeing running up and down the stairs holding red balloons. Employees have reported seeing apparitions of young girls dressed in Victorian attire standing near the stairway or at the front door to the casino. One employee said she even talked to one of the girls who was dressed in a blue dress and white buckle shoes. The girl said she was waiting for her daddy. When the employee held out her hand to the girl, she disappeared.

LILLY IS ANOTHER RESTLESS spirit roaming through the halls of a historic Cripple Creek building. The two-story Italianate brick building at 237–39 Bennett Avenue created a new building design when it was constructed in 1896. The use of brown brick to accent the center arched window was new to buildings on the commercial street. The rounded-edge design would later be duplicated on the Midland Terminal Depot and even later on the edifice of the Teller County Hospital. The building was known as the Turf Club, owned and operated by William P. Bonbright. An exclusive gentlemen's establishment, it held spacious rooms on the first floor for large meetings and billiard games. The second floor held private club rooms, as well as a few sleeping rooms for rent. The Turf Club was patronized by the influential businessmen of Cripple Creek, who also entertained their business associates who were visiting from out of town.

A year later, in 1897, intrigued by the concept of a gentlemen's club, John Harnan bought the business as well as the building from Bonbright. Harnan had recently become a very wealthy man. A stockbroker by trade, he was instrumental in helping the owners of the fabulously gold-enriched Portland Mine, Winfield Scott Stratton, James Burns and James Doyle, increase their mining claims from one-tenth of an acre to a staggering 130 acres. For his efforts, Harnan received a portion of the mine's dividends that year, which exceeded $900,000. Apparently, the Turf Club did so well that similar establishments were opened. However, while the majority of these businesses folded, the Turf Club remained a strong enterprise under Harnan's ownership until 1909. For the next eight decades, the Turf Club building would occasionally be leased to retail operators, but primarily it sat vacant. With such a gentleman's club history, how did the ghost of Lilly come to haunt this building?

As the human population of Cripple Creek dwindled during those decades, so did much of the ghost population. The past was largely forgotten as the town seemed to go into a slumber. Then, when legalized gambling was approved in 1991, Cripple Creek woke up. With the renovation of historic buildings, the ghosts of years past slowly returned. This seems to be the case with the Turf Club building. It was not long after the new Buffalo Billy's Casino opened adjacent to Bronco Billy's that staff members began to report odd happenings throughout the building. Doors would slam shut and glasses would fly through the air. Others would report seeing an apparition of a small child in the upper windows. Apparently, the young ghost was so real that many staff members reported seeing her and having conversations with her. On one occasion, a female employee saw a little girl sitting on a stair step. She joined the child and asked her what her name was. The girl replied, saying that her name was Lilly. The employee then asked her if she was lost, to which Lilly replied that no, she was not lost, she lived there. Startled by the answer, the employee then left to get a security guard. When the two returned to the stairway a few minutes later, the little girl was gone.

Tourists, hotel guests and gambling patrons have also reported having the pleasure of Lilly's company. One day, a woman was playing the slot machines. When she had finished, she looked around for her young daughter. Not seeing her child, the woman went in search of her daughter. She found her on the staircase sitting next to another little girl. The daughter explained to her mother that she was playing with Lilly.

It is said that Lilly loves to play. She has been seen with dolls and even balloons. Lilly also loves to draw and color. Employees of Buffalo Billy's Casino tell tales of seeing child's drawings on hallway walls and at the top of the staircase. Interestingly enough, after the walls are thoroughly scrubbed, the drawings eventually reappear.

The mystery of Lilly's identity is intriguing. A careful check of reliable burial listings of the Mount Pisgah Cemetery reveal several unmarked graves. Of the few grave markers with the name "Lillian" or "Lilly," there is one that could possibly be our Lilly. The small tombstone for Lillian H. Robush gives her birth date as September 15, 1908, and her death date as April 28, 1912. This would mean that Lilly Robush was three and a half years old when she died. As the original Turf Club building closed in 1909 but was periodically leased, it could be possible that little Lilly did live in the building before she died in 1912.

Then again, it could also be possible that Lilly got lost between here and the hereafter.

ONE OF THE NEWER brick buildings on Bennett Avenue is the Teller County Courthouse. The two-story brick building was erected in 1900, following the creation of Teller County (March 1899) with Cripple Creek as the county seat. At a cost of $60,000, the structure—90 feet wide, 120 feet deep and 40 feet high—was the largest in town. Inside, the government building featured polished hardwood floors, oak paneling, marble counter, gilt chandeliers, public water fountains and gold-plated electric fixtures.

A year later, President Theodore Roosevelt visited the headquarters of the county and held a brief meeting. In 1904, this building became headquarters during the second labor strike in the Cripple Creek Mining District. General Sherman Bell, head of the Colorado State Militia, placed sharpshooters on the roof and Gatling guns on Bennett Avenue in front of the county building. Mounted soldiers led arrested rioters and striking miners into the building, where they faced Judge Seed.

Today, very little has changed in both the exterior and interior of the courthouse. Teller County officials still work inside this historic building. Apparently, there are also ghostly spirits that seem to be waiting for some unknown event. An apparition of a miner is often seen climbing the central stairway to the courtroom. Is he looking for justice or awaiting his punishment? There are also rumors of an angry ghost in the basement that throws things and slams doors.

AT THE NORTHWEST CORNER of Bennett Avenue and Third Street is the impressive Fairley Brothers & Lampman building. The Fairley brothers, D.B. and C.W., established a successful furniture store on this corner lot in 1894. During the devastating fire of 1896, the store, along with 90 percent of Bennett Avenue businesses, was burned to the ground. The Fairley brothers were nearly financially ruined. In order to recover their business, the Fairleys took on a partner, Oscar Lampman, an undertaker. Lampman, who also served as a trustee on the town council, was instrumental in establishing Mount Pisgah Cemetery. Thus, with such influence, the new partners were able to construct a three-story brick building stretching the entire block of Third Street at the corner of Bennett Avenue. The building, known as the Fairley & Lampman Block, included the Fairleys' furniture store, as well as a variety of businesses. The third floor was rented out to BPOE #316, a very influential group in town, of which Lampman was also a member. This Elks lodge held meetings and events in one half of the floor and created a ballroom in the other half. On the main floor was Lampman's full-service

undertaking business. In a first for Cripple Creek, the mortician offered on-site embalming, coffin sales and funeral and burial services. Fittingly, Cripple Creek's most well-known ghost is said to occupy this "haunt." Mabel Barbee Lee writes in *Cripple Creek Days*, "As a child, I would cross the street away from the funeral parlor anytime rather than pass if there was death."

The Fairley & Lampman Building is a bit unusual. Due to its location on the high end of Bennett Avenue, it faces the Bennett side with three stories. Yet the Third Street side has an additional story on the lowered ground floor. This was the entrance used for the funeral hearses and carriages. It was also on this ground floor where the body of Cripple Creek's beloved Madam Pearl DeVere of the Old Homestead parlor house lay in state prior to her funeral. What better place to find ghosts than a former mortuary? Stories are told to this day of young schoolchildren creeping into the funeral parlor to sneak a peek at the corpse of the famed madam. Even a youngster like Mabel Barbee couldn't contain herself from stealing a peek when it came to the death of the town's beloved madam, Pearl DeVere.

In September 1901, a boisterous, rich mine owner, Sam Strong, shot his mouth off one too many times. At the Newport Saloon on Bennett Avenue, J. Grant Crumley aimed his shotgun at Strong and blew off half of Strong's head. His body was brought to Lampman's place, where he embalmed Strong as best he could. Some believe that weird sounds and occasional cries in the night are those of Pearl DeVere and Sam Strong.

In the autumn of 1918, a severe outbreak of influenza swept across the country. Colorado's death rate was one of the highest in the nation, and this included Cripple Creek. Undertaker Oscar Lampman's mortuary, on downtown Bennett Avenue, became the repository of the deceased. At times, bodies were actually stacked outside the mortuary. Funerals were limited to only four mourners. In an effort to save time, the local ministers and priests often accompanied the doctors as they made their rounds to the residences.

One of many ghosts said to haunt the walls of the Fairley & Lampman Building is known only as Maggie. Reported sightings go back to the 1960s, when the first floor was remodeled for an ice cream parlor called the Sarsaparilla Saloon. The new owners of the building, Kenneth and Katherine Hartz, heard footsteps in the night from the floors above. After the Elks lodge vacated the third floor for its own building, the ballroom was extended to cover the entire floor. As the nightly footsteps continued, the owners decided to venture up to the third floor to investigate. Having never been up there before, they were aghast at the sight. Beautiful wood floors were shadowed by dingy windows. Dozens of chairs and tables cluttered

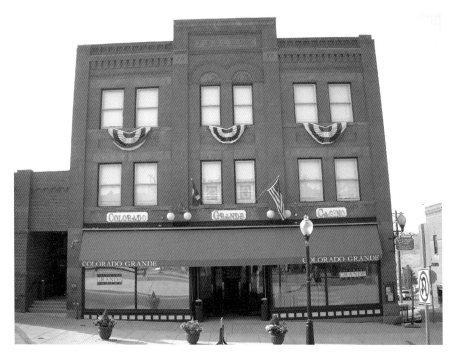

This building was known as the Fairley-Lampman Block and housed the town's mortuary. Today, it is the host to many ghosts, including Maggie. *Author's collection.*

the huge, unoccupied ballroom, while the wallpaper, mildewed and stained, peeled away from the walls. With a sudden realistic glimpse at the past, Kenneth and Katherine Hartz realized they were indeed living with the past.

In an attempt to contact the ghost, the owners held a séance using a Ouija board, popular at the time. Not surprisingly, given the building's history, both Kenneth and Katherine said they saw a group of men in dark suits chatting in a corner of the ballroom. Nevertheless, Maggie, as she was known, continued to make her presence known. Strange blue lights flickered eerily along the stairway and down to the second floor, which the Hartzes had transformed into their living quarters. Kenneth and Katherine would close the doors to the staircase, but someone or something would open them. "We would tie them shut with a twisted coat hanger," Kenneth said, "because we couldn't lock them. We would go downstairs knowing there was no one upstairs, but we'd come back and find the hangers untied and the doors standing open."

One day in the fall of 1968, Katherine was cleaning on this same stairway. She later described what happened: "I was walking down the stairs, and I

heard sounds like someone was upstairs with high heels on, walking above me. I realized that in order to do so, whoever it was had to be walking through the walls upstairs." Just as Katherine turned on the stairway to go up to the third floor, she said she saw a young woman with brunette hair piled high on her head with no hat, standing on the same stairway just above her. The apparition was dressed in a white blouse and long blue skirt reminiscent of the Gibson girl style popular around the turn of the century. There was also a slight aroma of rose perfume. It is said the Victorian-dressed apparition greeted the new owner through mental telepathy, and the owner answered the same way. Katherine later said she spoke to the female ghost, saying, "You are welcome to stay in this building as long as you protect it, take care of it and as long as you're here only for the good." Katherine and her staff would often hear music playing in the ballroom, yet there were no instruments in the room. From time to time, they would also hear their ghost sing Irish tunes in a melodic soprano voice.

Shortly after this discovery, the couple decided to rent the third floor to western artist Charles Frizzell, who had his art gallery on the first floor. It wasn't long before Frizzell began experiencing the same oddities as his landlords. The footsteps continued, and occasionally Frizzell could hear the taps of high heels as if gliding in dance across the ballroom floor. Frizzell told me he even heard piano music coming from the ballroom. Investigating the room at the end of the third floor always turned up nothing. Frizzell also felt the presence of Maggie:

> *After a long day in the studio, I would climb the wide staircase to the third floor. The double doors would almost always be open, even though I had locked them every morning. So my friend Jerry Hollings and I would lock the doors each morning and then fasten a wire coat hanger around the door knobs. Still, the doors would be wide open when we arrived back on the third floor.*

For the most part, Maggie has held to Katherine's wishes, although she can be mischievous from time to time. Lights would be turned on after the building had been closed for the winter. When Katherine received the electric bills, proving the usage, she asked Maggie to turn off the lights. The usage stopped. Katherine recalled the time when the money in the cash register went missing for a time. It was closing time at the Sarsaparilla Saloon, and part of the routine was that one of the employees always took the cash from the register and placed it on Katherine's desk in her second-floor office.

However, when Katherine sat down at her desk to do the accounting, the cash was not there. The employee swore he put it there. They checked the register, which was empty. It was then that Katherine realized what was going on. As she caught a whiff of rose perfume in the air, Katherine said she yelled out to Maggie, "Maggie, put that money back where it belongs." A short time later, Katherine checked the register, and the money was there. In an interview, Katherine described Maggie: "My ghost is a beautiful human being. There isn't any story. She's just a nice person. There are a lot of nice entities in our midst."

Today, the building houses the Colorado Grande Casino. Its security cameras have actually caught what some believe is the ghostly image of Maggie. Apparently, the owners and staff are happy with her presence, as the first-floor restaurant is named Maggie's. In the fall of 2008, members of the Colorado Researchers of Paranormal Science investigated the building. Team leader and co-founder Terry Wardell later reported, "I do know that Maggie favored the female investigators with activity. In Maggie's [presence,] my own handheld video recorder went to standby mode the whole time. When we had a female investigator in with us, it stayed on the entire time, about an hour." Wardell continued, "We also had all five female investigators go down to the restaurant around 2:30 a.m. We sat around the large round table and started talking to Maggie, asking her to join us for a 'ladies' tea.' The rose smell became so strong that you could literally taste it in the air. It traveled around the room; we could follow it. This continued until we got a call from the men on the two-way radio around 3:30 [a.m.]."

According to Katherine Hartz, "Maggie's been around dozens of times. In fact, she's never gone away. She's always around here, even if you can't see her."

ON THE NORTHWEST CORNER of Bennett Avenue and Second Street is the Bi-Metallic Bank Building. Rumor has it that eerie happenings occur within the walls of this historic structure.

When local newspapers declared Winfield Scott Stratton the first millionaire with the incredible production of his Independence Mine, new investors and entrepreneurs descended on Cripple Creek. Among them was David Halliday Moffat, Denver banker and railroad tycoon. Moffat's Florence & Cripple Creek Railroad rolled into town in July 1894, the same year he established his Bi-Metallic Bank. Highly respected throughout the

state, Moffat had no problem attracting customers, and no doubt his Bi-Metallic Bank also benefited from the many mine purchases.

When the bank building was lost in the April 1896 fires, Moffat wasted no time in rebuilding. The impressive two-story brick structure included polished wooden counters and floors, electricity and coal-fed furnaces. Moffat's bank did well for over ten years. When Moffat realized he could not compete against Albert E. Carlton's First National Bank, he sold the bank in 1905. A few years later, Moffat established the Cripple Creek State Bank, located in Johnny Nolan's building. Today, the former Bi-Metallic Bank building is owned by the Century Casino Corporation. In 1992, Womack's Casino occupied the majority of the building. During the opening ceremonies that year, the author was proud to cut the ribbon. Since that time, several casinos under different names have operated here before becoming simply Century Casino.

With so much business unrest, then as well as now, it is no wonder the building is said to be haunted. While I personally felt a cold spot or two, I never saw a ghost. However, other guests and staff members have reported seeing male apparitions wandering about, particularly at sunset.

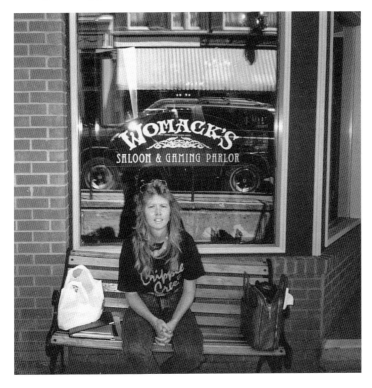

The author in front of Womack's Casino. *Author photo.*

THE PALACE HOTEL, ALSO known as the Palace Block, has been the center of Cripple Creek and its many ghost stories for over one hundred years. When the original 1892 hotel burned during the 1896 fire, the owner, Sam Altman, rebuilt on the same southwest corner lot at Bennett Avenue and Second Street. This time, Altman built with brick. Ironically, just two weeks earlier, Altman had received and refused an offer of $60,000 for the hotel.

According to the 1896 city directory, Dr. William H. Chambers rented an office at the pharmacy located on the first floor. The pharmacy is said to have stocked the most extensive supply of drugs in town. The soda fountain located on the first floor was quite popular with children and adults alike. It is the ghost of Dr. Chambers's wife, Catherine "Kitty" Chambers, that is at the heart of the Palace Hotel. Or is she?

Sometime during the 1970s, Kitty's ghost is said to have appeared time and again. At that time, it was said the good doctor's wife died in their living quarters, room number 3, in 1908. However, careful research by serious historians would conclude differently. According to Teller County court records, Kitty left Cripple Creek in 1903 after selling her half interest of the pharmacy to the doctor. Dr. Chambers left the town in 1910. The Palace Hotel and Pharmacy both went up in flames simultaneously. Therefore, Kitty Chambers could not have died in the hotel in 1908, as has been perpetuated. Yet the ghost stories at the Palace Hotel persist. Who is the ghost? In 1912, Mary B. Hedges became the hotel manager and lived in room number 3 on the third floor of the hotel until 1918.

Throughout the years, unexplained happenings seemed to occur at the Palace Hotel. In 1976, Robert and Martha Lays purchased the three-story brick building. Robert reported several incidents of table candles still burning following the hotel's closing for the night. Passersby would often see glowing lights coming from a third-floor room during the winter months, when the hotel was closed for the season. Later, the three Lays boys, Martin, Rick and Robert Jr., took over ownership and operations of the hotel. One evening when the hotel was closed, Robert was shampooing the carpet on the first floor. "I got a weird feeling of being watched," he said. He continued, "I don't get these feelings often. Then I heard a loud crash. I shut off the machine and looked around." That's when Lays saw his first ghost. It was that of a woman in a white Victorian nightgown, her hair flowing past her shoulders, walking down the stairs. Guests have also reported seeing the female apparition, either on the stairway or in the doorway. Guests would also get the feeling of being nudged when they were on the stairway. Room keys would also

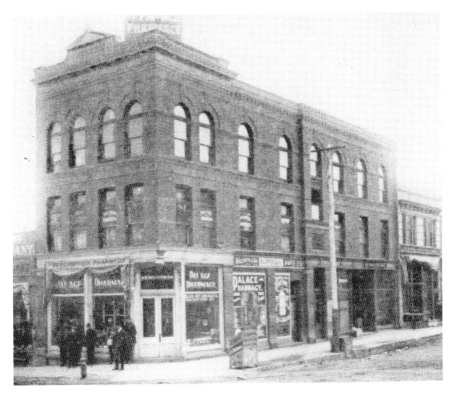

The Palace Hotel hosts the famed ghost known as "Kitty." *Mazzulla.*

disappear, particularly keys to room number 9. Lays recalled, "The first thirteen days we were open, we had six keys for room 9 disappear, and none came back." A few guests also reported seeing the female apparition in the lobby or on the stairs. "I know they saw her," Lays said, "because they supplied details I haven't told anyone." Since then, sounds of footsteps have abounded after closing time, eventually becoming a matter of routine speculation. Ghosts? Or folklore?

When gambling was legalized in the 1990s, the hotel became a casino. However, the casino owner filed for bankruptcy in 2001. A year later, Century Casino Corporation purchased the historic building and demolished the attached building for parking. Apparently, business was no better for the new owners, as the casino closed in 2003. The Palace Hotel building has been vacant ever since.

Today, the two original side doors of the building remain, with the words "Palace Pharmacy" engraved in the wood. The haunted history of the

Inside the Palace Hotel with a pharmacy on the first floor. *Mazzulla*.

Palace Hotel has been featured on the History Channel. The Southwest Ghost Hunters Association investigated the building in 2001 with positive voice recordings.

THE TWO-STORY RED BRICK building stands in solitude at the western edge of historic Bennett Avenue. Originally the Teller County Jail, today the building plays host to guests of the supernatural kind.

In the closing years of the nineteenth century, Colorado faced economic doom and gloom. That all changed when a new gold rush revived the state in a little-known area on the south side of Pikes Peak. The small gold camp grew at a startling pace. With the promise of gold wealth, the camp lured a variety of strangers. Among the hardworking miners, mining developers and businessmen were the bummers, the denizens and the dregs. Cripple Creek soon became a lively place to be, known throughout the West as a bustling, boisterous mining camp. After all, it is said the popular saloon song of the era "A Hot Time in the Old Town Tonight" was written with visions of Cripple Creek in mind. However, the song actually originated at a brothel in St. Louis approximately six years earlier.

By 1900, the once small mining camp had become a city, with over fifty thousand inhabitants. With the rapid growth came the obvious increase

in crime, both big and small—crimes of passion and crimes of greed and violence, typical in all mining communities.

During the early years of Cripple Creek's boom days, the town jail was part of the city offices. As crime increased, the need for a separate standing jail increased. The building at 126 Bennett Avenue was constructed during 1901. State-of-the-art equipment was installed, such as an interlocking push-button cell system and a steel cross-grid in the concrete floors, all at a cost of $25,000 to the county. The Teller County Jail first housed occupants violating the law in August of that year. For the most part, the Cripple Creek jailhouse held the common criminals of the mining camp, such as thieves and swindlers, card sharks, robbers, con artists, prostitutes and the like.

However, one of the first prisoners to be held in the fine new jailhouse was J. Grant Crumley, owner of the Newport Saloon. Crumley blew off half of Sam Strong's head with his shotgun over a gambling dispute. The horrendous murder of the local mine owner nearly created a lynch mob, yet thankfully, the sheriff and his deputies were able to calm the disgruntled crowd. Perhaps the most famous criminal incarcerated in the old Teller County Jail was a minor member of Butch Cassidy's Wild Bunch outlaw gang. Robert Curry (aka Bob Lee), a cousin of the more famed outlaw member Harvey Logan (aka "Kid" Curry), found himself under arrest after he freely spent marked bills stolen from the June 2, 1899 Wilcox train robbery. Arrested in March 1900, he was among the many prisoners transferred for a long stay at the new jail, where he was held for over a year until his federal trial.

There are two sections in the jail cell design. The central area of the main floor contains two levels of cellblocks. Over time, it became necessary to create a separate section of the jail for female inmates. On the second floor of the building, women, minors and even young children of female prisoners were incarcerated. At times, this section served as a makeshift insane asylum as well. Those unfortunate patients who could not be restrained at either St. Nicholas Hospital or the Teller County Hospital would be transported to the jail and locked in solitary cells. This area consisted of three jail cells; the "sick room," which was the separate locked cell for the insane; two rooms, including one for the jail matron; and one bathroom for the entire floor. The last door at the end of the corridor was the solitary confinement cell. A catwalk was installed between the second-floor cellblock and the windows, which was convenient for the guards to check on the prisoners.

During the hundred-plus years of the jail's existence, there were only two reported deaths inside the jail. One was that of a male prisoner who

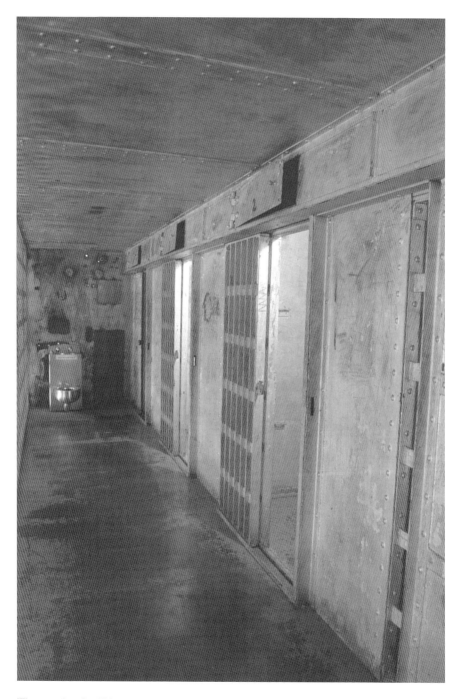

The two-tiered cellblock inside the jail. *Michelle Rozell*.

fell to his death from the second-level catwalk. Since then, strange sounds and dark shadows have been seen and heard at this spot when there is no other presence.

The other death was that of Olga Knutson. Clinically diagnosed as insane, she was brought to the second floor of the jail and placed in a straightjacket. For much of the evening of February 3, 1907, and into the night, Olga did nothing but scream and cry hysterically. In the early morning hours, Olga stopped crying. Shortly after sunup, the matron checked on Olga. She was dead.

In 1992, the Teller County Jail was closed. During the next decade, the building was vacant. Or was it? There are several tales of passersby seeing apparitions in the windows, particularly the second-floor window where the female prisoners were jailed. Others reported lights on at odd hours of the night; however, the electricity had long been shut off. Many began to believe that the building may be home to ghosts of the incarcerated past.

In 2005, the City of Cripple Creek approved the daunting task of refurbishing and renovating the old jail to house the new Outlaws and Lawmen Jail Museum. I was honored to be asked by the city administrator, Bill McPherson, to work with the staff on the historic aspects of the various museum displays and information. In 2006, when the building underwent major restoration, construction workers, electricians and museum exhibit workers told me of strange happenings within the walls of criminal history. Furnace lights would blow out with no explanation. Strange markings would appear on freshly painted walls. Cold air and strange smells would filter upstairs from the basement. They also told me of hearing strange whispering sounds when they were the only person in the area. None of the workers saw a ghost…or so they said.

Are there ghosts roaming the rooms of the historical jailhouse? Some say yes, they have seen the signs and felt the presence of such paranormal activity. On a tour of the museum, prior to the grand opening, I was present when the main cellblock's security door would not open when the proper levers were activated. Moments later, the doors opened without any activation. From the refurbished wooden staircase in the main room of the museum, footsteps have been heard when no one is on the stairway.

Since the opening of the museum, just about every paranormal investigation group in the state has spent time in the building. During the summer of 2007, Mountain Peak Paranormal Investigators spent some time exploring the refurbished jailhouse museum. Using their electronic

sound and visual technology, they were able to record sounds on their EVP equipment. However, none of their cameras picked up any images of apparitions during this visit. Later, another group, the UFOnut team, was able to capture several electronic recordings of mysterious sounds and even voices, as well as heavy breathing in the main entrance room. Yet no one was there. The same recording device was placed near where the prisoner fell to his death, and again, strange sounds and heavy breathing were recorded. On another investigation in 2011, the group reported extreme activity in the basement, particularly a space known as the "ice" room. At cell #3, designated for the insane, the heavy metal door began to rattle and clang. Several reported seeing a female apparition dressed in a brown skirt and Gibson-like white blouse. Could this be the jail matron? Or could it possibly be poor Olga Knutson?

In the area where the two cellblocks are located, the group smelled cigarette smoke in the non-smoking building. The team even managed to carry on a discussion with one of the jail ghosts that was caught on EVP equipment. From time to time, different paranormal groups lead ghost tours and offer investigations that are open to the public.

Perhaps the most unusual experiences have occurred when museum director Michelle Rozell and her group, Pikes Peak Paranormal Investigators, have hosted investigative sessions in the building. Rozell told me they like to hold sessions for the public in the solitary confinement area, as "that particular cell tends to have a lot of energy and we often get strange experiences and paranormal 'communication.'" This particular incident was no different. Rozell related what happened during the investigation:

> *Myself, three other investigators and three guests (one was my daughter) were in the solitary confinement area. One of the investigators and my daughter were inside the jail cell, and the rest of us were just outside of it. After a few hours in the dark, nothing happened. We all began chatting when suddenly we heard someone shout, "Get me out." Others said they heard "Stick it out." Regardless, we all heard the same voice, and one of the guests asked, "What the hell was that?" We had all heard a disembodied voice, and it was captured on multiple recorders. Later, when we listened to the recording, the voice sounded very mechanical and was nothing like what we heard in real time. Weird.*

Sometime later, Rozell asked her daughter what the voice sounded like to her, and she replied, "It sounded like he was standing right next to me."

Rozell has also experienced eerie encounters with the supernatural during her day-to-day activities as director of the museum. She gave me the following account of one such day:

> It was a regular business day in the jail museum. During the busy day with visitors, I ended up striking a conversation with a grandmother and her granddaughter. As we were walking, we were talking about prostitution history and paranormal activity in the jail building. We stopped at the solitary confinement cell and continued our discussion. Soon, I felt goose bumps from my wrists to my ankles. It was August—no cool air about that day. I told the ladies I needed to step out of the cell, as I was sure that "someone" was "hanging on to me." I continued to feel the goose bumps for another forty-five minutes. At that point, I actually said out loud, "Get off me. We are done here." The goose bumps were gone almost instantaneously.

Rozell had one more ghostly encounter story that she shared with me:

> It was in January or February, when the jail museum is only open Thursday through Sunday. I was in the museum alone except for a couple that were

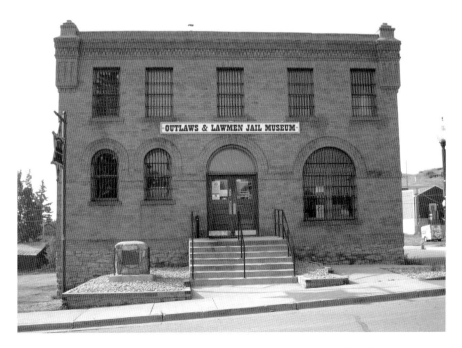

The Teller County Jail is now the Outlaws and Lawmen Jail Museum. *Rozell.*

The matron's quarters, where many have experienced eerie happenings. *Rozell*.

Jail Museum curator Michelle Rozell and members of a paranormal group often host ghostly investigations. *Rozell.*

> *touring the facility. After I had sent them on the tour, I went to the basement to grab some stock for the gift shop. Within a couple of minutes, I heard someone shout, "Michelle!" My first thought was "Oh my gosh, someone came in looking for me." I rushed up the stairs. The couple touring were upstairs in the female facility, and no one else was in the building. I went out the front door and looked up and down the street to see who I missed. There was no one on the street. I went back inside and began analyzing what had just happened. My conclusion was that I had heard my name; it was a male voice, loud but muffled. Deciding that the experience actually happened, I returned to the basement and said out loud, "You guys got me that time!"*

Several other people have told of feeling someone or something touch them. Others reported feeling as if they were pushed when no one was behind them. All believe this old historic building is definitely haunted.

Following the 1896 fire, nearly all businesses along Myers Avenue were rebuilt—in brick. On Myers Avenue, the majority of those businesses were brothels and bordellos. Today, only one establishment remains on the notorious street, and folks say it is haunted.

Myers Avenue, named for developer Julius Meyers, was one of the largest and rowdiest streets of ill repute in all of the mining camps in the West—the site of a legendary red-light district. Parlor houses were big business in Cripple Creek, as in any mining camp. Businesses on Myers Avenue operated twenty-four hours a day with free-spending miners who were out for a good time. Pearl DeVere and her Old Homestead parlor house filled that need.

Pearl was one of those ladies the "good" women of Cripple Creek didn't mention. Children were forbidden to walk near Myers Avenue, where Pearl ran her "gentlemen's entertainment" establishment. At the age of thirty-one, she had a head for business and made a very lucrative living from the beginning. Her ladies were encouraged to wear fine clothing and were paid well enough to afford it. The common women of Cripple Creek shuddered at these women who dared to shop on Bennett Avenue, the main business street of the town. Pearl was seen daily, riding her fancy single-seated phaeton, complete with red-painted wheels and led by a beautiful team of black horses. On horseback, she would wear a different elegant dress habit every day, riding sidesaddle, her derby hat cocked to one side, as she smiled brightly at people who stared. She was full of fun and had a kind heart. She generously gave to the charity causes in town monetarily, for she knew her presence wasn't welcomed at the various functions.

In April 1896, following the horrific fires, Pearl rebuilt her house of ill repute in brick. Pearl's new parlor house was quite extravagant, at least by Cripple Creek standards. Town gossip swirled at the expense Pearl spent to make her particular establishment the finest in Colorado. Lavish decorations, from imported European furniture to lace curtains and velvet draperies, adorned nearly every room. Large fireplaces and coal stoves heated the house on cold Cripple Creek nights. Crystal gaslights, as well as electric chandeliers, kept the house well lit during gay parties for the rich clientele. Running water was a luxury that improved the cleanliness of the establishment, not to mention the hygiene of the women. Hand-painted French wallpaper, at a cost of $100 a roll, gleamed throughout, and the finest handmade hardwood tables graced the parlor and entertainment rooms. There was a telephone and even an intercom system. The tongues wagged in Cripple Creek—electricity and two bathrooms, when decent family folk had coal lamps and outhouses.

Pearl's new establishment drew a rich clientele, where references were required of the guests.

On the night of June 4, 1897, Pearl gave a lavish party for her best clientele and business associates. For the occasion, Pearl wore an exquisite $800 Paris-made pink chiffon ball gown, complete with sequins and pearls. It must have been quite the affair, especially for the small mountain mining camp. Pearl greeted and mingled with her guests throughout the night and into the morning hours. Upon retiring, just before sunrise, Pearl was quite restless and took a dose of morphine to sleep. Still dressed in her beautiful and expensive pink chiffon ball gown, Pearl eventually fell asleep. Sometime later, one of her girls checked on her and found Pearl breathing sporadically and was unable to wake her. Dr. Hereford was summoned and did all he could, but the morphine had taken effect. An hour later, on the morning of June 5, 1897, thirty-six-year-old Pearl DeVere died.

Pearl's body was taken to the Fairley & Lampman funeral rooms, and Coroner Marlowe was sent for. The coroner ruled the death as an "accidental overdose of morphine." However, some contend it was intended. Others say it was accidental. It is said her family thought she designed dresses for the wives of Cripple Creek's millionaires rather than provocatively entertaining the millionaires themselves. According to local legend, Pearl's sister arrived from the East for the funeral. Seeing the corpse of her sister with dyed auburn hair at Fairley Brothers and Lampman's funeral parlor, the sister also learned the truth of Pearl's profession. The sister immediately left Cripple Creek, never to be seen again.

Many citizens of Cripple Creek were shocked when they learned of the sister's behavior. Pearl's generosity was known throughout the mining town yet often ignored during Pearl's life. With her death, Pearl became endeared to the hearts of Cripple Creek's townsfolk. The *Cripple Creek Times* ran a banner headline: "Cripple Creek Can Bury Its Own Dead!"

An auction was spearheaded by Johnny Nolon, Cripple Creek businessman and owner of the popular Johnny Nolon Saloon. However, during the arrangements, an anonymous envelope containing $1,000 in cash, postmarked from Denver and addressed to Fairley Brothers and Lampman Undertakers, arrived, paying all expenses and directing that Pearl be buried in the elegant pink ball gown.

Pearl DeVere was buried with much pomp and circumstance on a cold, cloudy June day in 1897. The fire department band led the procession, playing the "Death March." A full parade of carriages followed the hearse carrying a lavender casket covered with red and white roses to the

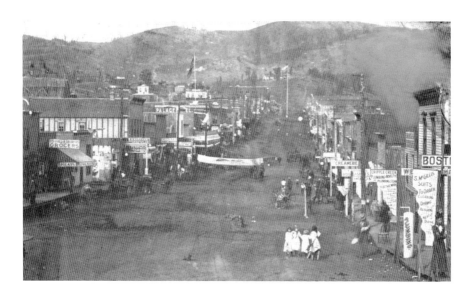

Above: Perhaps one of these little girls playing in the street also played inside Johnny Nolon's Saloon, which is said to be haunted by the apparition of a small girl. Or possibly one of the girls is Lilly, known to roam the halls of the Turf Club Building. *Mazzulla.*

Left: The Old Homestead parlor house is now a haunted museum. *DPL.*

cemetery on the hill. Pearl was adorned in the elegant pink chiffon ball gown. Those in attendance included the common folk of Cripple Creek, influential businessmen in three-piece suits and miners, as well as the girls of the Old Homestead. All hung their heads as Pearl's casket was lowered into the ground. The people of Cripple Creek bid farewell and trudged solemnly down the dirt road to the town below the graveyard. Pearl DeVere became legendary, and the Old Homestead House become a Colorado legend.

Today, the Old Homestead House is a brothel museum, one of only three in the country. Established in 1958, the museum has retained the charm and elegance of its original owner. The original hand-painted French wallpaper and the original diamond-dust mirrors can be seen. Many artifacts in the museum were gifts to Pearl in an effort to rebuild her "house" following the fire or gifts to the working girls from admiring patrons. One such gift is the crystal chandelier in the entertainment room, a gift to Lola Livingston, one of the popular girls. In the dining room, a hand-blown glass chandelier hangs from the ceiling, a gift to Pearl. A silver tea service is also on display in the dining room, a gift to Hazel Vernon, who became the madam of the house following Pearl's sad death and was Cripple Creek's longest-reigning madam.

Volunteers of the museum, as well as several patrons, have reported oddities occurring throughout the house of yesteryear. Sounds of clinking glass come from the moving crystal chandeliers when there are no open windows. Objects move or disappear only to reappear a few days later. Cold spots are reported in various rooms. During the night or early morning, the sound of someone weeping can be heard, although very faintly. Some believe these are the cries of Pearl herself and that her spirit is still with the house. The museum staff carries on with her spirit. As museum curator Charlotte Bumgarner once said to me, "You can just feel it."

CRIPPLE CREEK'S LEGENDARY HOTELS are also said to be hosts to ghosts. The Imperial Hotel, the city's oldest, has been known to be haunted since the era of the Great Depression. Located at the northeast corner of Carr and Third Streets (a steep sloping corner lot), just off the main street of Bennett Avenue, the building was completed in late 1896. Built of red brick, the three-story building included twelve large arched windows, six on each of the upper two floors. In January 1897, the building was leased by a widow, Mrs. E.F. Collins. She named her establishment the Collins Hotel and

rented furnished rooms to professional men, assayers, mining engineers, stockbrokers and foreign investors.

In 1906, Mrs. M.E. Shoot bought the hotel establishment, making major changes and additions and renaming it the New Collins Hotel. Among the changes was the annexation of the three-story Roseberry Block building next door. An elevated passageway connected the two buildings. Under new management, the hotel boasted electric lights, steam heat, porcelain bathrooms and a dining room that could seat 150 guests. The hotel had seventy guest rooms on the upper floors of both buildings, furnished in the finest furniture and draperies.

While it was considered one of the finest hotels in Cripple Creek, Shoot nevertheless faced financial difficulties. When she was unable to meet her mortgage payments, the holder of the note, an Englishman by the name of George E. Long, foreclosed in 1910. Subsequently, George and his wife, Ursula, moved to Cripple Creek with the intent to operate the hotel for a time but stayed for forty years. As it turned out, Long was a descendant of British nobility and received quite a handsome yearly sum from the British Crown. With his wealth, he turned the hotel into a formal Victorian hotel. His first act was to change the name to the Imperial Hotel. Next, he ordered the finest furniture from the Daniels & Fisher department store in Denver, which was shipped by railroad to Cripple Creek. Then, he sold the corner building to the YMCA, retaining the hotel operation in the Roseberry Block building. The Longs continued the respectable service and amenities of the previous owner and added tourist services as well.

For thirty years, the Longs kept the hotel operating through the mining downturn and the Depression years. George Long fell to his death down the narrow basement stairs in 1940. Almost immediately, rumors abounded that his daughter Alice had either pushed him or hit him with a skillet. An accidental fall or forceful shove was never proven. Nevertheless, Mrs. Long struggled on with the hotel for four more years. In 1944, she padlocked the doors and walked away forever.

Perhaps coincidence, perhaps not, but this was about the time that Cripple Creekers began talking about seeing a male apparition in the windows. The ghost of George Long is said to roam the stairs and the basement. Alice is also known to roam the Imperial Hotel. A mentally challenged child, she was often locked in her room.

The hotel sat empty and decaying until Wayne and Dorothy Mackin purchased the building in 1946. With intense cleaning, remodeling,

The Imperial Hotel is host to several ghosts. *DPL.*

refurnishing and updating, the couple meticulously turned the Imperial into Cripple Creek's premier hotel. "We set our tables with crisp white linen, nice china and silver, and even candles in the evening." So wrote Dorothy Mackin. Soon, summer business was booming, while local groups booked parties and banquets. Business in the winter months was quite another matter. Looking to draw people to Cripple Creek year-round, the Mackins had been in contact with the Piper Players, a small theater group in Idaho Springs that was seeking a venue to perform. This evolved into the Imperial Players by 1948, and Melodrama at the Imperial Hotel was born. The infamous Red Rooster Room opened next to the lobby in 1953. A casual restaurant and bar, its appeal attracted locals and tourists. Incidentally, this was originally Alice Long's room. Not long after the Rooster opened, the wait staff reported hearing the sounds of scratching on the door to the room.

With statewide voter approval of gambling in 1991, the Imperial Hotel added limited-stakes gaming to its list of attractions and began operating as the Imperial Casino Hotel. With in-house hotel accommodations, guests can take their chances, as it were, at their own attempt at striking it rich. In 2010, longtime area residents Gary and Wini Ledford bought this historic landmark hotel.

In April 2013, the Pikes Peak Crypto and Paranormal group investigated the hotel. Glen Wilson sent me a video showing someone or something in a shadow form moving behind a table; there was no one in the room. Hotel staff have often talked of objects being moved during the night or feeling a presence when they were the only one in the room. Guests have experienced unusual noises, chair shuffling and various otherwise eerie happenings.

Today, the Imperial Hotel continues to welcome guests who stay among the permanent guests of the ghostly kind.

THE HOTEL ST. NICHOLAS is the other Cripple Creek hotel said to be haunted. This building, the city's first hospital, was the pride of the city. A century later, it bore the reputation of being plagued by encounters with those of the other side.

Just three short years after Bob Womack's gold discovery, the mining camp of Cripple Creek boasted nearly forty groceries and meat markets, fourteen bakery shops, four department stores and eight newspapers. Yet with eighty practicing doctors, there was no hospital in this remote area. Cripple Creek citizens appealed to the Catholic Sisters of Mercy to help them with opening a hospital, as they had in other Colorado communities. To entice the Sisters to Cripple Creek, the citizens donated a wood-framed house, located at 326 East Eaton Street. In late 1893, Sister Mary Claver Coleman arrived in Cripple Creek to establish the town's first hospital, which opened on January 4, 1894, to all patients. Over three hundred patients were treated in the little house/hospital during that first year.

A devastating fire swept through the mining community on April 25, 1896. By nightfall, nearly the entire business district and surrounding houses were destroyed. Most of the houses on the west end of the town—although there were not many—were spared, including the new hospital. As the citizens began the cleanup process, four days later a second fire nearly finished off what the first had not. Again, the hospital survived the fire. However, the Sisters were convinced it was a sign and began plans for a larger and safer hospital. This hospital would be built of brick.

Arrangements were made, and the Sisters moved the hospital location a block away, with land purchased in 1896, at 235 East Eaton Street. (The original wood-framed house that first housed the hospital still stands. To date, it is a private residence.)

Denver architect John J. Huddart designed the three-story red brick building to be a state-of-the art modern hospital. Two elegant marble columns, rising two stories high, graced the extensive entry porch. Inside the hospital, the first and second floors were designed with rooms for patient care, while the third floor was dedicated to living quarters for the Sisters. It is said the hospital orderly lived in the attic. Cripple Creek's infrastructure was remarkable, given the transportation obstacles of the day. Construction of the St. Nicholas Hospital incorporated new technology by installing hot and cold running water, steam heat and electricity, used in the state-of-the-art operating room. The completed building project cost was an estimated $12,000.

Although they were not yet officially open, the Sisters of Mercy received their first patient on March 12, 1898. A miner, Elijah Ayers, was admitted with injuries suffered from a fall through the shaft of the Specimen Mine. The formal dedication, with great fanfare, was held on May 15, 1898. The Cripple Creek business directory of 1902–3 included an ad for the St. Nicholas Hospital: "Thoroughly Equipped with all Modern Improvements. Beautifully located. Best Physicians in the District in Attendance. ~ Telephone 73 ~ Corner of Third and Eaton Streets."

By 1902, the hospital had expanded the facility to better serve the community, as well as creating additional living quarters for the Sisters. In the continuing years, the hospital also included a school. Most of the citizens enjoyed and even benefited from the hospital's success, fondly referring to the hospital as the "Sisters' hospital."

In the autumn of 1918, just after the end of World War I, a severe outbreak of worldwide proportions became a pandemic, the first time the term was used. When it was over, influenza had taken over twenty million lives across the world—more lives than were lost during the war. All across Colorado, including Cripple Creek, influenza took over six thousand lives between September 1918 and June 1919. Colorado's death rate was one of the highest in the nation, affecting primarily young, otherwise healthy males. The St. Nicholas Hospital was overflowing with patients. There were not enough doctors and nurses for such a catastrophic emergency. Nevertheless, doctors and nurses worked around the clock, saving those they could, quarantining those they could not.

The haunted St. Nicholas Hotel was originally Cripple Creek's first hospital. *DPL.*

Following the influenza epidemic and the subsequent economic downturn, mines closed, and a slow but steady decline in Cripple Creek's population occurred. During those years, the hospital continued to serve the community while operating the school and opening a convent. In 1924, after thirty years of medical service, the Sisters of Mercy left Cripple Creek. Dr. W. Hassenplug led a group of doctors who bought the hospital. The facility was used as a private hospital until 1960, when it was sold to the county for one dollar. The City of Cripple Creek then took over the hospital administrations.

The St. Nicholas building became a semi-hotel and boardinghouse for several years. The last tenant moved out in the 1970s, and the building remained vacant for two decades. It was during this period that citizens of Cripple Creek first became aware of eerie happenings inside the old hospital building.

In 1995, the wonderful century-old hospital was bought and restored to the grand luster of the Victorian era. After a year of renovation from top to bottom and nearly half a million dollars, the Hotel St. Nicholas was transformed into a wonderful blend of a hotel and bed-and-breakfast inn, complete with Victorian atmosphere and relics of the bygone era. From the original porch entry into the main lobby of the hotel, the history of the building is evident. Fifteen rooms were available with all the expected features and a few extras with the premium rooms. On the main floor

of the hotel is the Boiler Room Tavern, so named for the cast-iron front plate of the hotel's original coal-burning boiler, which now serves as the tavern's decorated back bar. The massive boiler, weighing in at well over one thousand pounds, heated the entire three floors of the hospital, using some one hundred pounds of coal each day. In the office of the hotel is an enormous safe believed to have been in continual use in the Cripple Creek Mining District for over one hundred years.

The Hotel St. Nicholas has a history of ghostly encounters. Unexplained events have been reported, including a couple of mischievous ghosts lurking around the old hospital. There are the sightings and shenanigans of an apparition known as little Petey, a child who was a patient at the hospital around the turn of the century. From time to time, little Petey has been seen in the building, but his presence is usually known when small objects such as silverware, candles or keys seem to be moved or hidden with no explanation. Another friendly ghost has been sighted in the form of a miner who is seen at the back stairways of the building. There are also sounds of mysterious creaking floorboards along the hallway.

The Hotel St. Nicholas has even hosted several ghost-hunting groups, including the Southwest Ghost Hunters Association. Other spirits roaming the halls of the Hotel St. Nicholas include the apparition of a headless male wandering in the lobby and bar area. Another is known to be present by his smell. This male ghost lurks in the rear of the building and smells of sewage, hence his name: Stinky. However, by all accounts, these ghosts seem to be of a friendly sort.

In the northwest section of town is Cripple Creek's second hospital building. Not only was it a place for human healing, but it also had its share of death. Perhaps that's why people hear things that go bump in the night and others speak of spooky shenanigans.

In 1900, following the creation of Teller County a year earlier, one of the commissioners' first acts was to appropriate funds for a county hospital. Designed by C.E. Troutman, the two-story red brick building featured Romanesque Revival elements such as rounded arches, stone lintels and round columns. However, the most impressive feature was not one but two two-story porches: one for general patients' convalescence and relaxation and the other for tubercular patients. Inside, the brick walls were three feet thick. The hallways and main stairway were designed wider than usual to accommodate stretchers and gurneys. Most of the patient rooms were on

the second floor, as was the operating room located on the south end of the floor, with plenty of large windows to provide the best lighting.

When completed in 1901 at an amazing cost of $20,000, the new Teller County Hospital contained the finest state-of-the-art medical equipment. When the new hospital opened on May 2, 1902, one of its first patients of record was thirteen-year-old Roy Bourquin. The young lad was deemed to be a pyromaniac, having set many fires in Cripple Creek. His latest dynamite stunt went horribly wrong. When he was admitted to the hospital, both of his arms had been blown off as a result of the accident. When the hospital staff notified his parents, the Bourquins abandoned their son, leaving him at the hospital as a ward of Teller County. Roy Bourquin spent the majority of his life at the Teller County Hospital, often in the insanity ward. Finally, well into his forties, Bourquin was transferred to the state mental institution in Pueblo.

For the next twenty years, Teller County Hospital services were in high demand. However, when the mines became unprofitable, many families left the region. Even more folks left the county during the Great Depression and World War II. It was during this time that Minnie Gongway, superintendent of nurses, was put in charge of operating the facility as a nursing home. The new operation barely managed to stay open, finally closing in 1961. This grand brick building sat vacant for nearly two years.

In 1963, the Mackin family, owners of the Imperial Hotel, purchased the former hospital from the county. The goal for the Mackins was to convert the empty and decaying building into a hotel that could provide for the overflow of guests at the popular Imperial Hotel located in the center of town. With intense cleaning, remodeling, refurnishing and updating, the Mackins meticulously turned the old hospital into a fine hotel on the outskirts of town. In addition, a large portion of the land was transformed into Cripple Creek's premier RV park. The Mackins named their new hotel the Hospitality House.

With state-legalized gambling in 1991, the Mackin family took on a second remodeling in an effort to create additional guest rooms. Colorado Springs architect David M. Barber was hired for the job. The central two-story front porch was enclosed with glass, and the second story of the other front porch was torn down. The end result was an inviting circular porch. Inside, extreme care was taken to preserve as much of the original hospital atmosphere as possible. Original woodwork was restored, Victorian carpet was laid and over seven hundred rolls of reproduced period wallpaper were hung throughout the building. To create a mini-museum of sorts, the

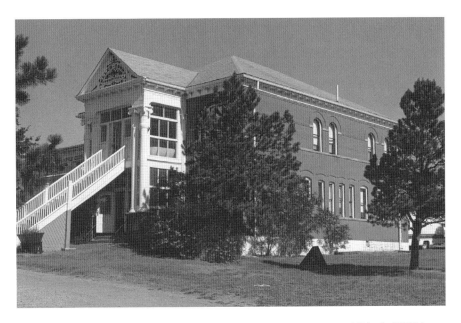

The Teller County Hospital opened shortly after Teller County was established. *CCDM*.

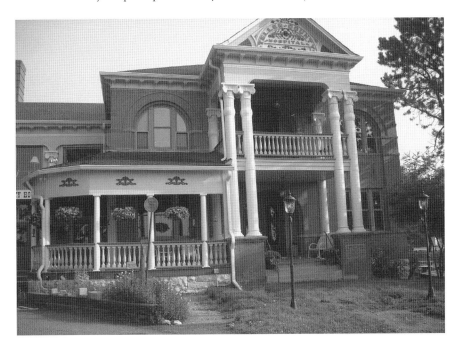

Today, the hospital building is the Hospitality House, a bed-and-breakfast with many ghosts. *Author's collection*.

Mackins even restored many pieces of original hospital equipment, such as several wheelchairs, gurneys, a crib and even the original operating table.

Today, the Hospitality House offers eighteen guest rooms, including the former operating room. Hotel staff have reported seeing objects move when no one is around, having missing items suddenly appear and feeling cold spots in the former operating room. An apparition of a male dressed in a suit and dress hat is said to wander the halls of the second floor. Could it be old Roy Bourquin?

The former hotel proprietor, Steve Mackin, once said, "The hotel has great energy, which we ask all guests to respect."

CARR MANOR, LOCATED ONE block north of Bennett Avenue, on the southeast corner of Carr Avenue and Fourth Street, has quite a history of unexplained supernatural occurrences. The two-story red brick building was constructed in 1897 to serve as the Cripple Creek High School. In 1901, an expansion project began that took four years to complete. The two-story addition at the north end included an auditorium and a gymnasium. The Romanesque-style corner bell tower and pitched roof completed the exterior design in 1905. Among the graduates that year was Ralph Lawrence Carr, who would

The haunted Carr Manor was originally the high school. *Rozell*.

go on to be governor of Colorado in 1939. During Carr's term as governor, the school was able to add a large outdoor swimming pool, thanks to the government's WPA project. For over seventy years, the building served as Cripple Creek's high school until its closure in 1977.

In 2003, longtime area residents Gary and Wini Ledford bought the old schoolhouse. The couple took on an extensive renovation project. When completed, Carr Manor was opened, offering fourteen rooms. Historic highlights included a ballroom in the original auditorium. Several of the rooms feature the original chalkboards.

Strange lights and orbs have been seen on the stairway at the second-floor landing. Guests have reported feeling a presence in various rooms of this bed-and-breakfast establishment.

CRIPPLE CREEK'S COMMERCIAL BUILDINGS are not all that are thought to be haunted. Several residential dwellings have rumors of the supernatural sort as well.

While fire devastated this town's businesses in 1896, many of the early homes, a few blocks removed from the Bennett Avenue commercial street, were spared. Eyewitness accounts, previous owner reports and a few undaunted homeowners have related tales of ghosts in their homes. As most of these homes are private residences, please respect their privacy.

Two blocks west of Carr Manor, at 315 Carr Street, is perhaps the most haunted house in Cripple Creek. It also is the former home of famed astrologist and author Linda Goodman. The two-story brownstone was built in 1898 by a New York accountant who moved west to work with the rich mine owners. He modeled the house after the popular style of single-family homes in New York City. The house sat on several lots and had a fabulous view of Cripple Creek below, as well as the Sangre de Cristo Mountains.

By the turn of the century, most of the mines had played out or had become too expensive to operate. It was about this time that Nikola Tesla rented the brownstone house while he conducted several of his electromagnetic experiments. According to the 1907 Cripple Creek city directory, this building was operating as a bordello. For the next several decades, the home changed ownership and even sat empty from time to time.

In 1968, Cripple Creek historian and director of the local museum Leland Feitz purchased the Victorian relic. While Feitz owned several rental properties in town, he chose to restore this house and live in it. Fresh paint,

new Victorian-style rugs and draperies as well as electrical updates were a few of the amenities Feitz included.

Ten years later, Feitz met Linda Goodman at a book signing event in Denver. The two seemed to hit it off, and Feitz invited her to Cripple Creek. In 1978, following the release of her second book, *Love Signs*, Goodman traveled to Cripple Creek. She immediately liked the quaint little mountain mining town. Goodman moved from New York City to Cripple Creek to experience a quiet, peaceful life away from the big city. Close friends say she wanted the mountain solitude, with no threat from fans and outsiders. She had no idea what she was in for when she bought the Victorian two-story brick home from Feitz, the preeminent local historian. She referred to her new house as "the little crooked house on the crooked little street."

Almost from the very first night she occupied the home, Goodman experienced sounds of unexplained music coming from all corners of the house. During the day, she would occasionally see male and female apparitions in Victorian dress. Various guests to her home also reported hearing unexplained laughter or the distant cry of an infant. No one knows for sure what Goodman experienced. Those who knew her say she was eccentric and recall her strange behavior. She could be seen stumbling along Myers Avenue, mumbling something to the effect of being in a time warp and relating to a prostitute. In her new home, she installed a large stained-glass window that depicted St. Francis of Assisi. She also built a lavish chapel setting where she practiced a self-designed religion of cosmic forces. Perhaps because of these acts or despite them, for no one knows, the haunting of her home continued. At night, she would hear music, people talking and vocal duets. Strange lights flickered and could be seen through the windows by neighbors and passersby.

In the early 1990s, Goodman's health began to deteriorate due to complications of diabetes. When she lost her leg to the disease in early 1995, she was forced to leave Cripple Creek for a health center in Colorado Springs. Linda Goodman died of heart failure on October 21, 1995. She was seventy years old. Cripple Creek friends honored her wish by scattering her ashes in the Mount Pisgah Cemetery.

Yet because there was no funeral, many fans of the author believe she never really departed at all. Perhaps they are right, for the eerie noises, moving objects and music have continued to be witnessed by new owners and their guests. Some believe it is Goodman. The flickering indoor and outdoor lights have also continued to be seen. Could this be the work of Nikola Tesla?

This brownstone house was built in 1898 and has a reputation of being quite haunted. *Rozell.*

Following Goodman's death, in early 1996, Rick and Janice Wood bought the 1898 brownstone as well as the boardinghouse next door. They were astonished to find many of Goodman's personal items had been left in the house. During the renovation, they left the decor as it was and only extended a few of the rooms. The boardinghouse was completely refurbished, a project that took sixteen months to complete. "We wanted to make sure we kept as much of the original structure as

Left: Famed astrologer Linda Goodman once owned this house and installed the stained-glass window. *Rozell.*

Right: The original outhouse remains, although unused, we think. *Rozell.*

possible," Wood said. A walkway was added to connect the two buildings. A portion of the boardinghouse was renovated for living quarters for the Woods, while the rest of the house was converted into a bed-and-breakfast establishment. When the project was completed, there were twelve guest rooms available at the former boardinghouse portion and six guest rooms, each with a private bath, available at the old brownstone. Just before the grand opening, Rick Wood gave me a private tour. As we walked from room to room, I asked him about the ghost stories I had heard for years. I was disappointed when he said he hadn't seen or heard anything. "I tell people if they want to see something, they will. I don't want to scare people away," Wood said.

Apparently, folks have seen "something," for there are a great many ghost sightings. Guests have talked of cold spots in their rooms and in the dining room. The apparition of a child has been seen on the first floor, but only in the morning hours. Most of the paranormal activity seems to occur on the second floor. Moving shadows have been seen in the Womack room. Framed

pictures actually shift or tilt and then return to their normal position. Guests in the Goodman room have reported feeling an unseen presence touch their arm or head. In the Feitz room, there have been reports of doors opening and closing and even locking on their own.

In 2013, Jason and Sofia Balas purchased the haunted historic property, but it was sold in the summer of 2017.

A FEW BLOCKS UP on Carr Street, across the street from the railroad tracks, was another reported haunted residence. Famed artist Charles Frizzell and his wife moved to Victor in the spring of 1969. By the end of that year, they had purchased the house in Cripple Creek. Frizzell soon learned that the house was originally a beer bottling plant and had been converted into a house sometime after the turn of the century. This accounted for the stone walls, which were thirty-six inches thick. The Frizzells spent the winter in Green Mountain Falls and drove to Cripple Creek on the weekends to work on their house remodeling.

"By the spring of 1970, we had completely moved into the house," Frizzell told me during an interview. "Almost from the beginning, I knew something wasn't right. The dogs growled at something or someone we didn't see. But I wasn't frightened—at first." The couple had only lived in the house for a short time before unknown entities began to overtake or retake the house. Frizzell said he barely got a good night's sleep due to the constant slamming of doors throughout the house. While renovating a room to use as his art studio, Frizzell discovered a small hidden door in the tiny hallway that led to the garage. This area was so small that Frizzell had to turn sideways to maneuver through the hallway and duck to enter the doorway. This door would be found open even after Frizzell knew he had closed it. He put a lock on the door, and still he would find it had opened. Then things began to disappear, especially keys. At first, Frizzell didn't think much of it. But when his replaced keys also disappeared, he began to question the strange occurrence. In an interview, Frizzell said, "You could not keep keys in that house at all; you would never find them." One night, the front window of the house shattered. Frizzell recalled, "It exploded out into the yard. It was like something you would see in a movie about ghosts." Frizzell told me this is when he began to believe in the supernatural. "It was too obvious not to believe," he said.

All these phantom shenanigans began to take a toll on Frizzell. He couldn't concentrate, and his work suffered. On the advice of his

friend Linda Goodman, Frizzell contacted a man who dabbled with the supernatural. He told Frizzell that some sort of evil spirit had attached itself to Frizzell's aura. Frizzell wasn't sure about that, but he was certain that there was a diabolical spirit of the dead lurking in his house. The Frizzells held a séance in their home where they used a Ouija board to make contact with the spirit. The board spelled out "now you have joined us." Frizzell and his guests were skeptical and tried the board again. Three times in a row, the board spelled out the same thing: "now you have joined us." Frizzell and his guests were beyond frightened. They moved into a different room, where Frizzell built a fire in the fireplace in an effort for everyone to regain their composure. He was not sure if it worked, but the supernatural guru told him that the spirit in the house had died when it was being built over one hundred years ago. He suggested to Frizzell that the house be cleansed. Frizzell told me, "In the winter of 1971, we cleansed the house with a ceremony which included burning sage and cedar and carrying sweet grass and feathers throughout the house. We were told to place something 'good' in the home, so my wife found a Bible."

Frizzell also said that after the cleansing, he no longer felt the presence of the evil spirit, but the opening of doors and other eerie things continued. Thus, by the spring of 1972, the Frizzells took leave of the house as quickly as they could.

This begs the question: was Frizzell driven out of the house by a poltergeist? Recently I posed the question to him, and he didn't answer.

The house was sold to Blevins Davis. Actress Shirley MacLaine was a good friend of Davis's and often spent time in the home. In time, Davis had to have the house cleansed again, or so Frizzell was told. Years later, the house was demolished to make room for parking amid the onslaught of casino gambling in the former mining town.

THREE BLOCKS FROM CARR Street is Aspen Street. The dirt street extends north up a hill to a renovated home known to be haunted. One of the previous owners—there have been thirteen—lived with a lively ghost presence for over twenty years. This unique house looks nothing like it did when built in 1890. Then, it was a three-room log cabin. Unfortunately, there are no records of the earliest owners. Over the years, this private residence has been completely upgraded with electricity, plumbing and running water and has received additions, renovations and ghostly guests.

In 1974, Russell and June Sylvain purchased the two-bedroom ranch home. Little did they know the house came with its own ghost. The family that lived in the house before the Sylvains knew of the ethereal being. In an interview published in the *Gazette Telegraph*, June Sylvain said, "I was pretty open-minded when we moved in because the girls who were living there said, 'There's a ghost in this house.' I said, 'Oh, yeah, sure.'" There were also two young boys who told June of seeing a man dressed in a long overcoat and a derby hat.

It wasn't long after the Sylvain family had settled in that June began to hear strange sounds throughout the house. The floors would creak and the windows would rattle even on calm weather days. Perhaps the ghost was just testing the new owners, for soon after, he made himself known. At first it was just in the kitchen. The sound of glasses clinking together could often be heard. Kitchen drawers would open and close on their own. Heavy footsteps, as if stomping, could be heard across the hardwood dining room floor.

When the Sylvains' teenage son, Russell Jr., began missing personal items such as clothing and books, he decided to investigate. He and his girlfriend worked with Russell's Ouija board. They got the name "Ed," and then the Ouija board gave them what they thought was a surname: "O'Brien." Interestingly enough, historical records do show a Ted OBrien who actually lived on Aspen Street, but not in the house the Sylvains owned.

June Sylvain later said, "We started calling him Ed. It's great to have that because when something disappeared, you could always blame it on Ed." Indeed, "Ed" got blamed for an awful lot of strange happenings during the time the Sylvains owned the home. "There would be a knock on the back door, and I'd go to answer it and no one would be there," said June. "Then, instantly, there would be a knock on the front door, and I'd be running back and forth. I'd say, 'Ed, stop it!' And it would stop."

One night, Russell Jr. fell asleep on the couch. He awoke when he heard a sound and saw the apparition of a man standing in the archway between the living room and the dining room. He had on a long overcoat and a derby hat, just as the young boys had described to June Sylvain. June said she never saw an apparition while living in the house, but she believes her dogs and cats did. She said the dog would bark at the wall and the cats would stare at something she could not see. When this happened, June said that the fur on the animals would stand up and they would become very nervous. A few years after Russell Jr. uncovered "Ed" through the Ouija board exercise, June made a discovery of her own. While digging for old bottles in her yard one

Families often had picnics in the Mount Pisgah Cemetery, which is said to be haunted. *CCDM.*

day, she found a silver fork with the letters "O B" engraved on the handle. Could it be "O'Brien" the ghost?

In time, the Sylvain family grew accustomed to "Ed" the ghost. June said, "I never feel alone in the house, even when I am. But it's not a bad feeling. You just learn to live with it. I don't want to move; I love the old house." But move they did. They sold the house in 1995 and moved farther west to another small mountain town—minus "Ed."

AT THE WEST END of Cripple Creek, the town cemetery sits on a hill. Like so many cemeteries, this one is rumored to be haunted. Mount Pisgah Cemetery was established in 1892. In that year, there were two mining camps, Hayden Placer and Fremont. Each was competing against the other to attract businesses. In an effort to consolidate the two camps, the real estate firm of Bennett and Myers seized the opportunity and promptly offered an amicable compromise for both camps. Bennett and Myers, owners of Fremont, deeded a forty-acre section of their property, which lay against the eastern slope of Mount Pisgah, to the new town to be used for a cemetery. Ed De LaVergne and the other leaders of Hayden Placer recognized that their town plat was limited regarding growth. Therefore, the two competing mining camps of Fremont and Hayden Placer agreed to consolidate, and a new cemetery was the consolation prize. It would be forever known as the Mount Pisgah Cemetery.

Among the thousands of marked graves, there are an estimated two to three thousand unmarked burial sites. This cemetery is where Linda Goodman's ashes were scattered. Marked burial plots include those of Pearl DeVere and the large Robush family plot with the grave of three-year-old Lillian H. Robush. A large plot enclosed with a wrought-iron fence bears the name "Nolon." There are no burials in the plot, as Johnny Nolon moved his family to Nevada in 1903. A very interesting tombstone bears the name of Fred E. Krueger, who died at the age of twenty-eight; that is also the name of a character in the *Nightmare on Elm Street* horror movies.

Shadowy apparitions are often seen near the iron gateway. Flashes or light streaks and orbs have been reported, particularly at sunset. Strange cold spots, as if a gust of wind is trapped by something unseen, occasionally occur. In 1998, during a cemetery tour I gave with history professor Thomas J. Noel, I personally experienced this at a family plot near a tree.

CHAPTER 3
THE RESIDUAL ECHOING EFFECTS OF PHANTOM CANYON

Victor can be reached by driving south from Cripple Creek on Colorado Highway 67 or east on County Road 64. Both routes are known for their colorful changing aspen in the fall.

From Colorado Springs or Pueblo, County Road 44/67 runs from Highway 50 through Phantom Canyon along the old Florence & Cripple Creek Railroad bed.

> *Any person blessed with a with a lively imagination can people its fantastic rocks, piled high in serried columns with all sorts of phantoms, goblins and spooks.*
> —*John Sanford, 1905*

Who or what is the phantom of Phantom Canyon? There are many historic accounts of events in the canyon, as well as stories of legend and lore. Perhaps the phantom is the Indian hunter or the cries of an Indian maiden or maybe the buried Chinese railroad workers, or possibly it is just the wind through the canyon. However, there are those who believe that the canyon got its name after a ghost sighting in 1896. Legend has it that the apparition was dressed in a prison uniform and was seen walking along the railroad tracks in the canyon. It is said that the male ghost had recently been executed at the Colorado State Penitentiary at nearby Canon City. Another phantom tale is that of an 1880s Indian love story that ended tragically. During the fall hunting season, a small band of Ute Indians

were camped not far from the mouth of the canyon. It was during this time that a group of westward travelers passed by in their prairie schooners and entered the canyon. On the second day of travel through the thirty-mile canyon, the pioneers became stranded by an early winter blizzard. Members of the group set up a makeshift camp as best they could, cutting a few trees for firewood. After a few days, a small group of warriors led by Kaswind entered the canyon in search of the traveling white people. Finding the stranded group faring quite well, Kaswind offered to help with gathering wood and water. It was while he was bringing water to the white women that Kaswind first saw Rowena. It is said from that moment that Kaswind was smitten with Rowena.

Perhaps that is one of the reasons Kaswind instructed the women of his tribe to move their camp next to the opening of the canyon. It was not long before Kaswind was carrying the water every day for Rowena. This did not go unnoticed by Dark Flower, who was betrothed to Kaswind. As the days went on, resentment and jealousy consumed Dark Flower. Early one morning, Dark Flower hid herself in the bushes at the spring where Rowena retrieved her water. Shortly after sunrise, Rowena walked the path to the spring. As she filled her water bucket, Kaswind walked toward her. Suddenly, Dark Flower ran toward Kaswind and grabbed his knife. She ran to Rowena and stabbed her in the back. Joe Marsh, the leader of the white travelers, ran to Rowena's side as he heard her screams. As Rowena's body slumped to the ground, Marsh turned toward Kaswind, raised his pistol and shot Kaswind through the heart. Dark Flower managed to escape undetected and notified the warriors that the whites had killed their leader, Kaswind. The warriors mounted their ponies and rode toward the canyon. It is said that their war cries echoed among the canyon walls as they killed every one of the white travelers. To this day, the trees, shrubs and rocks take on eerie shapes as the sun sets in Phantom Canyon.

This incredibly narrow canyon, thirty miles in length and located between Victor and Canon City, has a storied history indeed. The road was carved from the dirt and rock in 1892 and was known as the Florence Free Road. This was an alternative route to the nearby toll Shelve Road. Both roads led to the newly established Cripple Creek Mining District.

Two years later, railroad tycoon David H. Moffat built the Florence & Cripple Creek Railroad through the canyon. Engineers devised a way to create two tunnels through a mountain, shortening the train travel time considerably. However, during one of the many dynamite explosions,

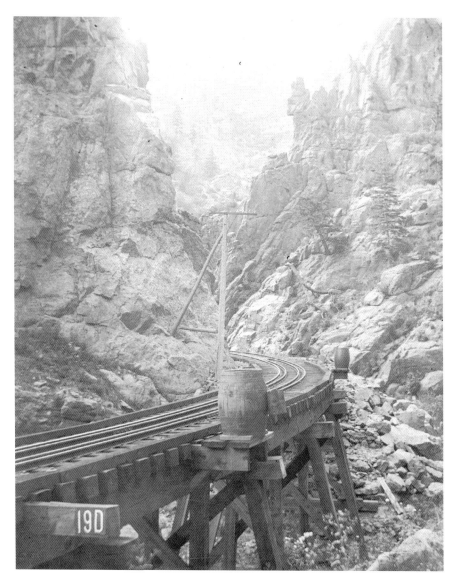

The Florence & Cripple Creek Railroad travels through Phantom Canyon, where many workers died and are said to haunt the canyon. *DPL*.

something went horribly wrong, and six Chinese rail workers were buried alive under hundreds of tons of crumbling red rock.

Nevertheless, construction of the narrow-gauge rail line was completed, with two dozen trestles and two tunnels, in just six months. On July 2, 1894, nearly all of Cripple Creek's citizens lined both sides of

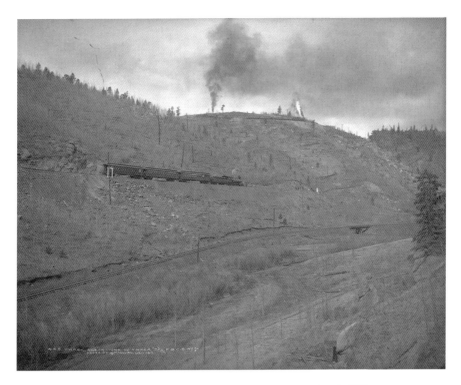

The Florence & Cripple Creek Railroad climbs toward Cripple Creek. *DPL.*

Bennett Avenue to witness the arrival of the first train into their town. The townsfolk would not learn until after the celebrations were over that the last passenger car had jumped the track near the mining camp of Anaconda, plunging approximately forty feet down an embankment. Twenty-one passengers were injured, and there was one fatality, that of W.G. Milner.

In 1912, a flood with an estimated thirty-foot-high wall of water roared through the canyon, severely damaging the railroad tracks. In 1915, the railroad tracks were dismantled. Three years later, in 1918, the dirt road, which climbs to 9,500 feet, was graded and opened to motor vehicles.

It is said that the railroad often had an added passenger: a female ghost. No one knew her name or where she boarded or departed the train. Only the railroad employees saw her; that is to say, no other passengers mentioned her. The green-eyed beauty was said to have a shapely figure when she walked the aisle of the passenger car. The lovely apparition smiled sweetly when she noticed the men staring at her. Railroad workers also saw the

vision of beauty standing on the platform at the various depots throughout the mining district. When the train stopped, she would board and ride to the next stop, where she often vanished in thin air.

 No one knows who she was—perhaps a lost lonely lady or maybe one of the passengers aboard one of the few trains that derailed on or near the canyon.

CHAPTER 4
THE HAUNTING OF VICTOR

Cripple Creek's rival mining town, Victor, is known as the "City of Mines," and with good reason. There were actually more mines in the vicinity of Victor than Cripple Creek. One of Victor's rich mines was right in the center of town. By 1900, over $18 million worth of gold had been mined near Victor. Today, many of Victor's businesses and homes have a history of strange sights and sounds that offer no apparent rational explanation.

In 1893, Warren Woods, a Denver businessman, arrived in the mining district with his sons, Frank and Harry. Looking over the area at the foot of Battle Mountain, they intended to develop a town site. The Woods Investment Company laid out plans for a new town on November 6, 1893. It was called Victor, for Victor C. Adams, a local homesteader. At twenty-five dollars per lot, land sold quickly, businesses were built and a true mining town was formed. When the Woods brothers broke ground for a new hotel, darn near in the center of the new town, they struck gold. Their future pay dirt came from the gold, not the hotel which became an investment. And that's how Victor, literally, became the City of Mines.

While the Woods brothers actively promoted their town site, by early 1894, they had begun construction of the much-needed hotel in the growing mining town. While grading the land for the hotel, at the corner of Diamond Avenue and Fourth Street, Frank Woods hit a twenty-inch vein of gold right in the heart of the mining town. Construction of the hotel immediately ceased, and the Woods brothers traced the vein of gold to the Gold Coin claim, which they quickly bought for a few thousand dollars. A shaft was

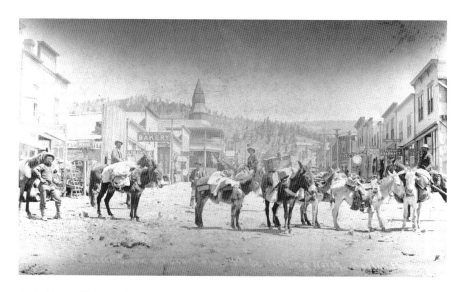

Early Victor. Note the first Victor Hotel on the left with the steepled roof. *DPL*.

The Gold Coin Mine, with the smokestack, sits in the middle of town. *DPL*.

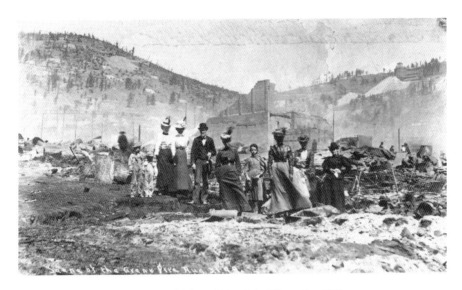

This group poses for a picture amid the rubble of the Victor fire. *DPL.*

sunk in the middle of the strike, and the Gold Coin Mine was erected on the main thoroughfare of Victor. Within a year, the Woods brothers' Gold Coin Mine was producing $50,000 a month, and by 1899, an average of $200,000 was the returned dividend to their stockholders.

In the meantime, the Woods brothers bought another lot, downhill and a block south, for their Victor Hotel, built at the southeast corner of Victor Avenue and Fourth Street. The opening of the hotel, in July 1894, coincided perfectly with the first completed rail line into the district: the Florence & Cripple Creek Railroad.

Disaster struck in the form of a raging fire on a hot afternoon on August 21, 1899. Beginning in the red-light district known as Paradise Alley, between Third and Fourth Streets, the fire swept through the entire town of Victor, burning nearly every structure, including the Victor Hotel, in less than five hours. When it was over, fourteen square blocks lay in smoldering ruins.

The Woods brothers, along with most folks in Victor, wasted no time in rebuilding, relocating the hotel across the street at the corner of Victor Avenue and Fourth Street. The new structure, built of brick, was nearly fireproof. The four-story pale brick building, rectangular in shape, commanded a large portion of the commercial block. The grand opening was held on Christmas Eve 1899, among a cheery crowd who very much needed something to be proud of in their newly built town.

Much larger than the first hotel, this building was built to accommodate businesses, as well as serving Victor as its finest hotel. The first floor provided private offices for lawyers, mining engineers and bankers. In fact, the First National Bank of Victor, owned by Frank and Harry Woods, located on the first floor, had two entrances: one from Fourth Street and the other from Victor Avenue and the building lobby. Inside the large and open lobby, dominated by Romanesque arches at the windows and doorways, with intricate woodworking, the lobby featured an elaborate elevator, complete with wrought-iron bars and a safe locking door, the first in the mining district. The largest bank vault in the district safely held the majority of the local mining wealth in gold and currency. Despite the safety measures, the elevator mechanics failed on at least one occasion, resulting in death.

The upper floors were all decorated in the finest wallpaper designs of the era, and the ceilings were of intricately designed metal. The second and third floors held businesses, and guest rooms were on the fourth floor, with conveniently located bathrooms along the hallway. The comfortable rooms rented for $2.50 a night. By the turn of the century, the fourth floor of the hotel had been transformed into a hospital of sorts. Here, emergency operations were performed, including appendectomies.

Today, the Victor Hotel retains the same Victorian charm as in yesteryear. Perhaps the finest building in town, this hotel is also well known for its ghosts. What's more, the proprietor readily acknowledges the fact. A plaque on the wall of the lobby reads: "Our hotel dates back to 1899. It is common for old buildings to make noises due to the age of the structure and normal conditions such as temperature changes and settling."

In the early 1900s, a local miner by the name of Eddie often stayed in room 301. Leaving for work early one day, Eddie went to the "bird-caged" elevator and pressed the down button, as was his custom. When the door opened, Eddie stepped forward, but the elevator wasn't there. Eddie fell through the elevator shaft to his death. It is said that Eddie's body was taken back to his hotel room and laid out for burial preparation. Today, guests in room 301 often don't stay the entire night, hearing footsteps and other unexplained sounds. Staff members report that on occasion, the well-maintained elevator mysteriously activates on its own, always stopping on the third floor.

Other rooms seem to have ghostly inhabitants as well. Guests in room 307 often complain of banging pipes. A corner room, there are no pipes running on either side of the room. Other guests report missing or moving items such as glasses, keys and bath towels.

Hotel staff as well as guests have claimed to see "Charlie," an elderly man with a good sense of humor. The description of Charlie is always the same: a man slightly humped over, dressed in torn jeans and a plaid shirt and wearing a black hat.

During the Christmas season of 2003, a young woman was seen on several different occasions walking through the lobby late at night. She always stopped in front of the decorated Christmas tree. When hotel staff would approach her, she disappeared.

Another ghostly tale related a few years ago comes from a hotel guest who chose to remain anonymous:

The hotel was mostly empty when we were there. We saw only two other guests at the hotel who were seen coming in and out of room 309. Nothing was said about ghosts during check-in. The fellow in the office wore a Scottish kilt and seemed congenial. [He] mentioned that after 9:00 p.m., the office would be closed, and in the event of an emergency, a phone number listed on the in-room information guide could be called.

My mother and I were assigned room 304 and my daughters room 305. We carried our bags into the rooms and began to settle in. We opened the windows to let in fresh, cool air from the outside, as there is no air conditioning.

I returned to our car to gather a few more items. Upon entering the antique cage elevator, I pressed the button for the third floor. The elevator took me slowly and creakingly to the fourth floor, and the doors opened. I looked at the panel and saw the fourth-floor button lit, and I stepped into the hallway and saw no one there, heard nothing and verified the doors were labeled as room numbers in the 400 series. I reentered the elevator and pressed 3 again. The doors closed, and the old elevator took me back down to the third floor.

Then, I entered my daughters' room, bringing to them some items from the car, and closed the door to the room after entering. We talked for a few minutes, and then I mentioned the incident of the elevator taking me to the wrong floor, and just as I said it, the room window slammed shut violently, smashing the lace curtains half in and half out of the window. My youngest daughter gasped. I went to the window and raised it back up, and the curtain rods suddenly came apart and fell to the floor. I fixed them and went back to my room, where my elderly (age seventy-nine) mother was waiting.

Upon entering my room, I related dinner plans (we had noticed that a saloon in town serves pizza), but my mother said she had become ill suddenly; she had been stricken with a sudden onset of diarrhea.

Later that night, after dinner with my daughters, we returned from our walk to the saloon, and I noticed a light coming on in a room on the fourth floor. I thought someone must be staying up there. We went to our rooms and all settled in for the night. My mother was in bed and still not feeling well.

Sometime after midnight, my sleep was disturbed by what sounded like a commotion on the fourth floor. I could hear what sounded like furniture being moved and doors shutting. There were also sounds of heavy footsteps on both the third and fourth floors, along with unintelligible voices.

About 3:00 a.m., I awoke from a nightmare, but I cannot remember the dream. My awakening was sudden, startling, and I was immediately frightened, but I didn't know why or the exact cause of my fear. Then I heard loud tromping on the fourth floor. This was some kind of seemingly violent disturbance. Voices were heard that sounded like a heated argument. Doors were slammed shut up above. I then heard people walking in the corridor of the third floor. Then more disturbances up above on the fourth floor. Sounded like some heavy things were dropped on the fourth floor (upon my room's ceiling). There was a feeling of stress, tension, something wrong. Eventually, the noises subsided, and I fell back into sleep, awakening in the morning.

All of my family members reported hearing strange noises during the night. My oldest daughter said that she was awakened at precisely 3:00 a.m. (she looked at the clock next to her bed) with the sound of the wrought-iron elevator doors opening on the third floor and "a man huffing, puffing and wheezing, running from one end of the hallway to the other and back again, sounding like there was some emergency or some serious trouble." She said she became very frightened but after awhile was able to fall asleep again. Others reported very disturbed sleep and "strange noises all night long."

The two guests we saw staying on the third floor looked like miners with typical mining clothes, and one even carried a helmet. They were very dusty and dirty. They didn't say anything or even acknowledge my presence with a smile or grin when I nodded my head at them and said hi. They just had expressionless faces. Other than the manager, these two miners were the only other people I ever saw in the building. We did not see them in the morning when we checked out. Later, I learned that none of the other members of my family there saw the miners. I was the only one that saw them, and I saw them just after the elevator took me to the wrong floor and I came back down to the third floor. As I exited the elevator on the third floor, I looked down the hall, and the room door was open where these guys were, and one of them came out and got in the elevator as I was exiting it. These two were expressionless and very dirty. No one else saw them.

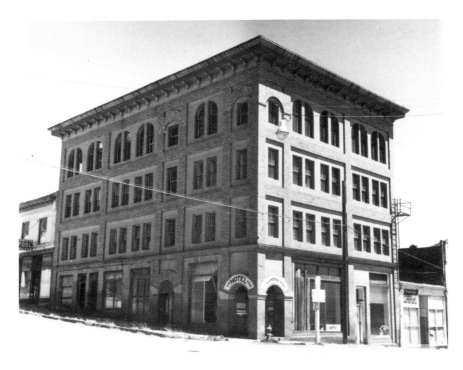

The new Victor Hotel, built after the fire, was the pride of Victor. *Maria Cunningham.*

The hotel lobby where ghosts are known to hang out. *Cunningham.*

When we checked out, the manager was not in the office. He had a handwritten sign at the desk that said, "Manager is on the fourth floor doing maintenance. If you need to check in or speak with the manager, please come to the fourth floor. We have vacancies." I had already prepaid for the rooms when we checked in, so I just laid the keys down on the desk, and we drove off to go to Cripple Creek for lunch. By the way, as we were leaving the hotel, my mother said she felt 100 percent better and had no lingering illness whatsoever.

The hotel's iconic ornate iron-caged elevator remains a focal point of both history and ghost stories. It also served as transportation of a different sort in the early 1900s. With frozen ground during the winter months, graves at the Sunnyside Cemetery were impossible to dig. The fourth floor of the hotel held the bodies, transported by the elevator, until springtime and warm weather thawed the ground. There have been several guests reporting sightings of ghosts on the fourth floor. Apparitions of headless ghosts, those without arms or legs and even those that look to be doctors have been reported.

THE WOODS FAMILY WERE among the very few mine owners who gave back to their community. The Gold Coin Club, across the street from their rich Gold Coin Mine, was built for the miners who worked at the mine. When it burned in the 1899 fire, the Woodses spared no expense in rebuilding. Patterned after the New York Athletic Club, the two-story brick building stretched an entire block. Inside, there was a game room, a bowling alley, a gymnasium, a swimming pool, a ballroom, a dining room with space for a large band and a library that eventually included some seven hundred books. The porch on the second floor was reportedly where President Theodore Roosevelt spoke to a crowd during a visit.

The bloody violent labor strike of 1903–4 led to financial difficulties for many mine owners, including the Woods family. When the family closed the Gold Mine Club building, Dr. C.E. Eliot purchased it. Here, he set up the Red Cross Hospital, which he operated for nearly fifty years.

Since that time, a variety of businesses have leased space in the historic building. While these businesses come and go, the poltergeists remain. Over the years, folks have also seen apparitions of miners and sick people in hospital gowns.

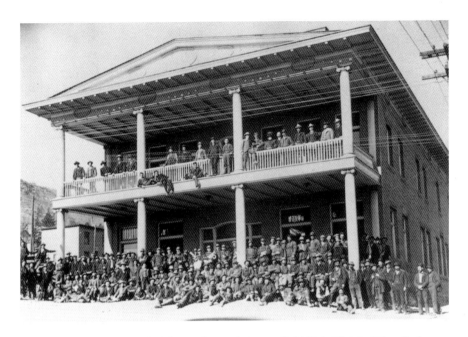

The miners of the Gold Coin Mine gather at their new Gold Coin Club building. Perhaps one of the fellows is the ghost that lingers there. *DPL*.

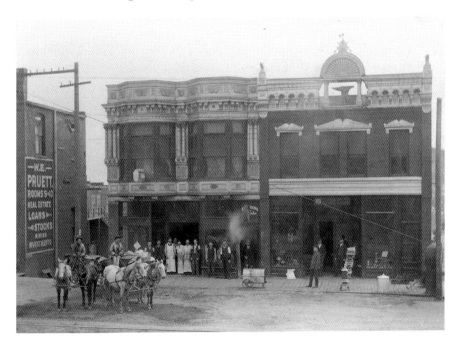

Perhaps the ghosts at the Union Hall building were disgruntled miners. *DPL*.

For years, residents of the small mountain mining community have talked of ghosts roaming the Miner's Union Hall. The two-story brick building on the southwest corner of Victor Avenue and Fourth Street contained tall windows with trimmed arches on all four sides. Inside, large meeting rooms were on the first floor and offices were on the second floor. It was through the second-story windows that folks would occasionally see the apparition of a male looking down at the street below. During the labor war of 1904, the Miner's Union Hall was the headquarters for the Citizen's Alliance and the Mine Owners Association. Clarence Hamlin, secretary of the Citizen's Alliance, gave a fiery speech to approximately one hundred members gathered in the street in front of the building. When Hamlin concluded with the words, "Run them all out, all their lice and nits too," one of the striking miners hurled a rock at a member of the Citizen's Alliance. A bloody brawl ensued. The Colorado State Militia fired shots to break up the fight. Several of the striking miners were arrested and held in the upper rooms of the Miner's Union Hall. Perhaps the male apparition in the upper windows was a striking miner awaiting his freedom. Unfortunately, in the summer of 2014, lightning struck the building, and it burned. Today, only the front façade remains of the haunted structure.

The Monarch Building, at the southeast corner of Victor Avenue and Third Street, is also said to be haunted. When famed artist Charles Frizzell left Cripple Creek because of ghosts, he arrived in Victor in 1974. He and a bachelor friend rented a room with a kitchen and bath on the third floor of the Monarch and soon began to experience similar phenomena as they had in Cripple Creek. Frizzell told me that while setting up his art studio on the third floor, he began to feel spirits roaming through the entire building. He described the first-floor landing as "very haunting." Frizzell said that the area was always cold, and others remarked on temperature as well. Frizzell related the following spooky story to me:

> *One night as I was descending the stairs, I felt a hand on my right shoulder. Suddenly, I was pushed down the stairs. I landed on the cold first-floor landing. My ankle had been twisted during the fall. I turned to see who had pushed me, but in the dim light of an outside streetlight, I did not see anyone. This was the first and only time I was ever touched by an entity.*

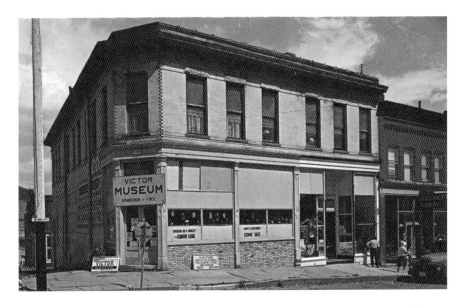

The Reynolds Block now houses the Victor/Lowell Thomas Museum and is reportedly inhabited by supernatural beings. *Victor/Lowell Thomas museum.*

Not long after this paranormal incident, Frizzell resorted to bringing a psychic friend of Linda Goodman's to the building in Victor. This psychic told Frizzell that there were at least a dozen unhappy spirits in the vicinity of the first-floor landing. However, by the time Frizzell's ankle had healed, he noticed that the first-floor landing was no longer as cold as it used to be.

During his four years at the Monarch Building, Frizzell and his buddy were often the only occupants of the building during the cold winter months. Frizzell would keep the building warm by stoking the furnace. Located in the basement, the furnace was in an area where the six-foot two-inch man had to bend down to enter and stay hunched over while shoveling the coal from the bin to the furnace. Occasionally, Frizzell would feel the spirits, but they never bothered him again after the fall on the stairs.

Frizzell lived here for four years. Years later, he recalled "feeling" a strange presence and seeing what he thought was a woman walk through a wall. Other guests reported seeing ghosts in their rooms and in the hallways. Light bulbs burned out almost weekly, and glasses moved in the kitchen area.

ACROSS THE STREET, AT the northwest corner of Victor Avenue and Third Street, is the Reynolds Block. Over the years, some tenants of this building have claimed that ghosts also occupy the space. Built of brick after the horrific fire on August 21, 1899, this building soon became the center of Victor's business section. In late 1899, Thomkins Hardware Supply Company and the Confectionery Store occupied the first floor. Later, the Victor Mining Stock Exchange had its offices on the second floor. At one time, it was the Hackley Hotel. Over the years, the building served as a grocery store and a furniture store.

Today, the two-story corner brick building houses the Victor/Lowell Thomas Museum. Here, the story of the "City of Mines," as Victor is known, is recounted in several exhibits in the historic building. However, as the name suggests, the main attraction is some of the personal items once belonging to Victor's son Lowell Thomas. It is said that the eyeglasses of Lowell Thomas move from one display to another.

During a visit to the museum in 1993, I experienced a cold spot near one of the displays. Museum curator Mike Moore said spirits occasionally make their presence known. On the upper floor of the museum, the apparition of a young boy by the name of Jake has been seen wandering through the rooms and is known to make a loud ruckus, which shakes the nerves of staff and visitors to their very core. The voice of a young girl has also been heard.

Paranormal investigations in the basement over the years have revealed many interesting observations, including apparitions of men in uniform standing among themselves.

AT THE VICTOR AVENUE intersection with Third Street is the historic Fortune Club Building. Current business owners swear it is haunted. Built following the 1899 fire, the three-story red brick building is Victor's largest surviving structure. Business directories listed the Fortune Club as a "Gentleman's Club." The first floor contained a large saloon, a gaming room with billiard tables and a gentlemen's smoking room. This is where members met women, made their selections and ascended the bare wooden staircase to the prostitution rooms on the second floor. One of the soiled doves, Red Stocking Lee, carried on a secret affair with the mayor of Victor. According to town folklore, when the city officials learned of the sordid affair, they ran the prostitute out of town.

Today, the building hosts the Fortune Club Diner, Hotel & Lounge. The original painted signs advertising whiskey, cigars and the like remain on the

side of the building. Glasses and bottles at the bar of the lounge have been known to break without provocation. Spirits of the four-legged variety also haunt the building. Employees have occasionally seen the apparition of a cat walking the length of the bar. Lights have been known to turn on even when no one is in the room. During a small redecorating project in the lounge, two of the employees saw the apparition of a woman, dressed in a black skirt and white blouse, grab a paintbrush from the bar and throw it on the floor.

In the basement, doors slam, and the kitchen staff have reported feeling a pounding sensation under their feet while cooking. However, the primary place for the paranormal activity is on the second floor, the former brothel. Creaking floors, footsteps and an occasional female apparition have been reported.

THE DUNN BUILDING, LOCATED at 213 Victor Avenue, is said to harbor the ghost of the original owner. Built shortly after the great fire, the two-story red brick structure housed the town's mortuary and funeral parlor. The very nature of such a business lends itself to all sorts of rumors of the supernatural.

Thomas F. Dunn, an undertaker by profession, set up his business on the first floor of the building. Living quarters for him and his wife were located on the second floor. The renowned mortician was known for his "artistic" abilities with the dead. It is said that Dunn had a way of cleaning up bodies that had been shot, dynamited, hanged, stabbed, fallen off a cliff or any other hazard awaiting a person in the mountain mining town. When he was finished, the corpse was suitable for viewing during the funeral.

Following Dunn's death, his widow retained ownership of the building. Mrs. Dunn rented out the first floor to local businesses and turned the second floor into an eleven-room boardinghouse of sorts. For the next few years, business was good for the widow Dunn. Then, a former assistant to T.F. Dunn came forward and began to tell a tale of terror.

According to this assistant, one evening he and Dunn were preparing the corpse of a miner for burial. The body had been horribly disfigured from a cave-in. During the process, the body suddenly began twitching. Startled, Dunn and his assistant jumped back from the embalming table. The arms of the supposed cadaver raised up, with one touching the eye socket that no longer contained an eyeball. The assistant said at that moment, the "dead" man began screaming. Dunn gave the man a heavy dose of morphine to ease the pain as well as stop the screams. It is said the mortician reasoned

that the poor man's injuries were fatal, and all a doctor would be able to do is prolong his life for a short time. Dunn felt that the injection of morphine would put the fellow out of his obvious misery. The assistant said that as the man was dying, Dunn continued with his burial preparations.

As time went on, Mrs. Dunn began receiving reports from her boarders of paranormal activity. Light bulbs would explode, cold spots would occur in the upper rooms and doors would slam shut. The building went through a series of owners following the death of Mrs. Dunn. One of the owners, Skip Phillips, often told of the spirits he encountered under his ownership. He would hear footsteps on the wooden floors and once saw the apparition of a woman dressed in Victorian clothing walking from room to room as if checking on the boarders. Phillips came to believe the ghost was the widow Dunn. He once said, "I love my ghosts."

Today, the Dunn Building serves as an apartment house. The original painted "Undertaker" sign remains on the exterior side of the building, and some say the ghosts remain inside.

THE KESSEY HOUSE, AT 212 South Third Street, is one of Victor's award-winning restored Victorian homes. This house has an interesting history that includes ghosts. The land where the house stands was a portion of the Spicer Lode, which was discovered in 1891. Three years later, the owners—J.C. Spicer, O.W. Spicer, Thomas Spicer and J.R. McKinnie—established the Spicer Milling and Mining Company. Later, this section was incorporated within the town limits of Victor, where a new residential section was created. In 1899, R.H. Atchinson, a member of the Spicer Mining Company's board of directors, built one of the finest homes for his wife, Mary. The two-and-a-half-story structure featured Palladian windows and a full front porch with a spindle banister. In 1907, Mary graciously rented one of her rooms to Mable Barbee Lee, who was a teacher at Victor High School for one term. One of her students was famed radio personality Lowell Thomas.

Following Mary's death, the house was sold to Oscar Anderson, owner of Anderson Meat Company. In 1919, Dr. F.M. Shipman purchased the house. In 1923, Dr. Shipman sold the home to Henry Curtis "Curt" Kessey. Two years later, Dr. Shipman was the attending physician at the birth of Kessey's granddaughter Carol. In 1945, Kessey sold the house to Wilma Jones. Then, in 1952, Curt Kessey's daughter (and Carol's mother) Pearl Kessey Haywood purchased the old family home. In the late 1970s, Carol and her husband, Ed, turned the house into a bed-and-breakfast establishment.

Carol often spoke of feeling another presence in the house even when she was alone. Carol would notice bedsheets turned down when she knew neither she nor her staff had done so. Little changes would be made, such as a vase moved from where Carol placed it or rearranged silverware. Over time, Carol became convinced that it was the ghost of Mary Atchinson, the original homeowner.

The local graveyard, Sunnyside Cemetery, is located south of town, reachable by following Seventh Street south. Although this cemetery is not rumored to be haunted, too many Victor citizens have experienced eerie happenings.

Because records were never kept, it is not known when the cemetery was established. However, the oldest marked tombstone is that of a nine-year-old girl who died in 1891. The ghosts that roam this cemetery are unseen. The only evidence are sounds of people whispering and of a train passing nearby, although there are no longer trains running in the region. Locals have reported streaks of colorful light, as well as dancing orbs on tall tombstones.

CHAPTER 5
GOLD MINES, GHOSTS, GOBLINS AND TOMMYKNOCKERS

'Ave you 'eard of the Tommy Knockers
In the deep dark mines of the West
Which Cornish miners 'ear?
And 'tis no laughin' jest,
For I'm a Cornish miner,
An' I'll tell you of it today,
Of the "knock-knock-knock" of a tiny pick
As we work in the rock and clay.
—old miner's ballad

As with any profession, there are legends and there are superstitions. For example, whistling in an ore mine was believed to bring bad luck. Women also brought bad luck, especially redheads.

Tommyknockers have been a part of mining legend for hundreds of years. In Colorado, miners believed that knocking and creaking sounds deep in the underground mines were made by "tommyknockers" or "knockers." The legendary tommyknockers were magical and even mischievous little gnomelike creatures. Approximately two feet tall and dressed as miners, they carried little picks and shovels and resided deep in the dark, damp mines.

The legend of the tommyknockers originated in Europe. In England, they were known as "English Brownies," and in Germany they were called *berggeisters*, which meant "mountain ghosts," or *bergmannlein*, meaning "little miners." Perhaps the best known legend is that of the Cornish miners of

Cornwall, England. In Cornwall, where the miners dug for tin, they had a high respect for the tommyknockers. They believed that the tommyknockers were ghosts of dead miners whose bodies were never recovered. If treated right, they would not harm the miners, but if disrespected, they would be ornery, making life difficult for the miners or, in some cases, ending the life of a miner. Many miners were so respectful that they would not enter a mine until they were reassured that the tommyknockers were already there. The Cornish miners were known for their keen senses and ability to avert dangerous situations. It is said they listened intently for the tommyknocker's warning. The knocking would start and grow louder and louder.

There is some truth to the legend of the tommyknockers. Hard-rock miners will tell you that there are strange sounds deep inside a mine. It could be the echo of the hammer and pick against hard rock, or it could be the creaking sound of the timber beams in the tunnels. Miners' superstitions were just as dark and spooky as the mines they worked in. In the days before adequate lighting, it would be easy for miners' eyes and ears to see and hear something entirely different than reality. Those who claim to have seen the tiny tommyknockers say they first appear in glowing lights followed by a strange mist. Others say if one actually sees a tommyknocker, he does not live to tell the tale.

A mine is a hole in the ground, owned by a liar.
—Mark Twain

In the mines of the Cripple Creek Mining District, tommyknockers were thought to be living down deep in the mines and brought both good and bad luck. To gain favor, miners would often leave a portion of their lunch behind. Conversely, if miners believed the tommyknockers had warned of danger, they would refuse to enter the mine, often causing a shutdown.

Some believe the Molly Kathleen Mine at Cripple Creek plays host to ghosts and maybe even tommyknockers. Today, it is open for tours, and the guides will talk of the tommyknockers if asked. It is said they often moved or hid a miner's tools if they were unhappy with him. For the miners they favored, tommyknockers might show him valuable ore.

In 1892, a mining claim was filed in the Cripple Creek Mining District for the Mamie R. Mine. Located on Raven Hill, approximately halfway between Cripple Creek and Victor, the Mamie R. seemed to be cursed from the beginning. Within the first year of full operations, three miners were killed, each in a separate accident.

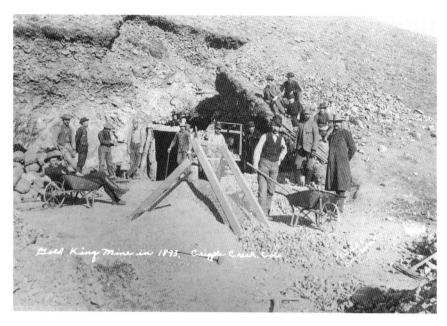

Miners at the Gold King Mine in 1893. Bob Womack is standing second from the left. *DPL*.

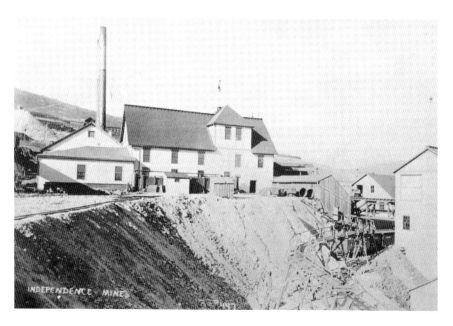

Some say Stratton's Independence Mine is haunted. *DPL*.

Most of the mines were hosts to tommyknockers, but the Mamie R. Mine had a particularly mean breed of sprites with evil intent. Most of the miners left to work in other mines that were deemed more stable. One of the miners who stayed was a big, husky man named Hank Bull. Bull and several miners arrived one morning to continue working on a new shaft they had dug. When Bull began to hear the cries of a child from down below, he asked the others if they heard it. None of them had. Finally, Bull went down the newly dug shaft. However, the shaft had not yet been stabilized with timber beams, and it was not long before the men heard a loud, hoarse scream from down below. The shaft collapsed, and Bull was buried alive.

For a while, the tommyknockers seemed to just be mischievous, pulling pranks on the miners. Miners would see partial apparitions when descending down the mine shaft. But the main focus for the tommyknockers was the windlass that lifted ore and miners out of the mine. A bell attached to the windlass would be rung three times, signaling the men to raise the contraption. Often, after the bell was rung and the apparatus raised, it would be empty. In November 1894, the windlass fell and hit a man, crushing his skull. After that unfortunate incident, miners began to see a headless miner walking in the darkest areas of the mine. Another ghostly miner would often appear in the hoist but disappear when it reached the top of the mine. A few days after this incident, A.P. Garson, who ran the boardinghouse near the mine, fell desperately ill, dying nine days later. On November 15, E.D. Blake replaced Garson, only to succumb to the same ailment within a few days.

On Christmas Eve of that year, 1894, the mine flooded. The miners spent most of Christmas Day hauling out buckets of water. During one of the raisings, the apparatus broke apart, with pieces flying through the air and back down the shaft and the rope coming loose. Somehow, the flying rope wrapped itself around the neck of one of the miners and,

An ore bucket like this also hauled miners in and out of the mines. *Rozell*.

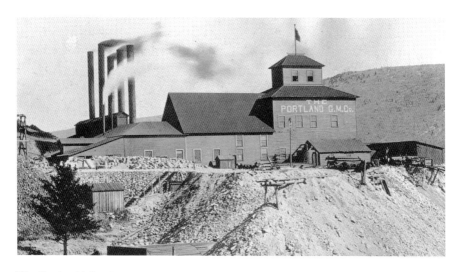

The Portland Mine became the richest mine in the Cripple Creek Mining District. *DPL*.

It is said eerie things happen at the remains of the Mary McKinney Mine site. *DPL*.

pulling tight again, decapitated the man. The miners did not return to work, and the owners were unable to hire new help. In January 1895, the mine closed, never to reopen. In this case, the evil tommyknockers prevailed.

Today, there is very little talk of the legendary tommyknockers, most likely due to the lack of mining. However, archived interviews, part of the WPA works of the 1930s and 1940s, contain remembrances of miners and their tales of tommyknockers.

CHAPTER 6
GOLD CAMP GHOST TOWNS

The familiar rough shanty of the average western mining town and its narrow, squalid streets, are here replaced by well-kept lawns and neat, comfortable residences.
—Cripple Creek Morning Times, *January 1, 1899*

Following Bob Womack's gold discovery, Colorado experienced the last great gold rush in American history. To provide housing for the thousands of miners who flocked to the mining district, no fewer than twenty-two mining towns were established. Many of these were eventually swallowed up by bigger towns or merged together.

> *The very dust of the streets of Camp Goldfield is impregnated with the precious metal, and is not the ground beneath honey-combed and seamed with drifts and stopes and cross cuts and veins and deposits of gold?*
> —Cripple Creek Evening Star, *New Year's edition 1904*

Just east of Victor, at the junction of U.S. Highway 67 and Teller County Road 81, is the old mining town of Goldfield. Old mine shafts, headframes and cabins still dot the landscape here in the Colorado high country—with maybe even a few ghosts.

Goldfield was founded in 1895 by three of the richest men in the entire state: James Burns, James Doyle and Winfield Scott Stratton. They were millionaires from the nearby Portland Mine. The three established the town

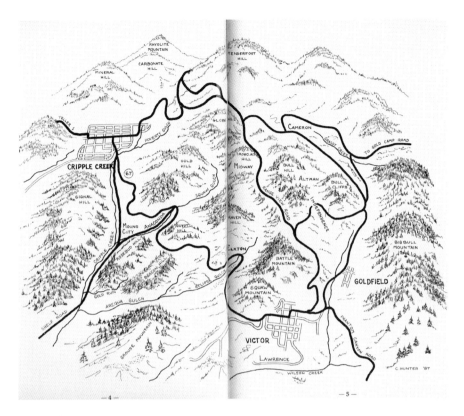

Map. *Brian Levine.*

for their employees and their families. By 1900, the population was over three thousand. It was called the "City of Homes," as it had the finest-built structures of all the mining towns. Although Victor was just a mile away, Goldfield had its own school and several churches. The town boasted a two-story brick building where the city's business was conducted, as well as its own power plant, the La Bella Electric Company. This plant provided electricity to Anaconda, Goldfield, Independence and as far away as Victor and Cripple Creek. The freight yard for the Florence & Cripple Creek Railroad and a depot were located here.

During the labor strike of 1903–4, Goldfield was at the epicenter of the conflict. The Colorado State Militia set up a tent camp at the base of Battle Mountain, which was just below the Portland Mine. When the bloody conflict ended, the mine owners hired new workers who had not been involved in the strike. By 1910, the Portland Mine was producing an annual average of $30 million worth of gold.

Today, the city hall still stands in the center of the once busy town and is now in the National Register of Historic Places. Many homes, from small cabins to modest clapboard houses, have survived, although some in better condition than others. People still live in Goldfield, which has a year-round population of approximately thirty. It is said that one can hear the sounds of wailing coming from the hills, and occasionally a male apparition has been seen in the town.

AT THE EASTERN BASE of Bull Hill was the ghost town of Altman. One of the most populated mining camps in the district, today the population consists of only a few wandering ghosts of yesteryear.

Sam Altman, who was the first to establish a sawmill business at Cripple Creek's Poverty Gulch, owned the Free Coinage Mine on Bull Hill. Altman founded the gold camp in 1893, naming it after himself. Established at 10,620 feet when incorporated, Altman was the highest town in America. From its perch on Bull Hill, the town of Victor could be seen below and America's mountain, Pikes Peak, nine miles away, stood tall to the northeast.

Along with the Free Coinage Mine, the town served the American Eagle, Isabella, Victor and Pharmacist Mines, just to name a few of the hundred mines in the vicinity. The Pharmacist was discovered and so named by two druggists who simply threw a hat in the air and began digging where it landed.

With so many miners working so many mines, the town quickly grew in population to twelve hundred residents by 1894. While the mines dominated the area, the town soon covered the entire top of Bull Hill with several saloons, including the Silver Dollar and Monte Carlo; boardinghouses; grocery stores; hotels; restaurants; and even boardwalk sidewalks. By 1897, two hundred log and frame houses dotted the hillside, and the population topped two thousand.

Primarily a union town, Altman was the headquarters for the striking miners during both labor wars in the Cripple Creek Mining District. John Calderwood, the leader of the Western Federation of Miners (WFM), first organized the miners at Sam Altman's Free Coinage Mine, with promises of an eight-hour workday and a salary of three dollars a day. The mine owners refused to negotiate and formed the Mine Owners Association (MOA) to combat the miners' union. Because Altman was located so high, it offered panoramic views of the region. Therefore, Calderwood and members of the WFM chose it as the location to set up their camp, which included a

kitchen tent and horse stables. Miners were required to show their member cards to armed guards scattered throughout the town of Altman. Sabotage, kidnapping and murder took place during the summer of 1894. Governor Davis Hanson Waite called out the state militia. In the end, several of the miners were arrested, and others were driven out of the district, never to return. Shortly after the strike, *Leslie's Weekly Illustrated* sent a reporter. In describing the town of Altman, he wrote, "The town is garish and beastly prosperous" and includes "a sizable number of saloon keepers, tin horn gamblers and faded soiled doves."

By 1896, Altman had organized a city government and built a fine school. However, violence returned to the mining town in the form of theft, shootings and murder. At one point, there were so many deaths as a result of gunshots that the local undertaker offered group rates on Saturdays. Altman was actually the only other mining town, besides Cripple Creek and Victor, to have a jail, which was put to good use. "General" Jack Smith was the leader of a group of thugs that had been causing trouble in the district for

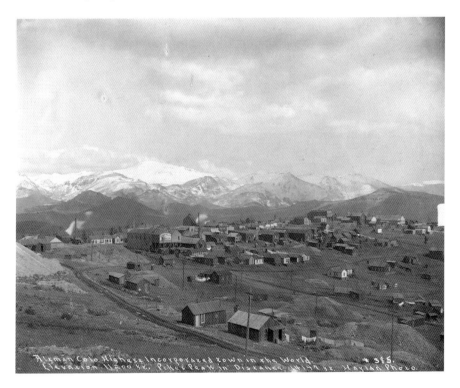

Altman was once a booming mining town. *DPL.*

years. When he arrived in Altman to break his cohorts out of jail, Marshal Jack Kelly was waiting and promptly arrested him. Once Smith posted bail, he immediately made his way to the nearest saloon. When Marshal Kelly walked in, Smith pulled his pistol and fired. The shot missed, and the marshal's return fire hit Smith square in the chest. Later, Sheriff Mike McKinnon encountered another group of bandits. When they opened fire on the sheriff, McKinnon managed to quickly reciprocate, killing all six before dying of a gunshot he had received.

In 1903, a fire destroyed nearly half of the town. Three hundred of the five hundred homes and businesses burned, a result of arson supposedly to collect the insurance. The arsonists had cut a water main and covered their tracks with black pepper to impede the bloodhounds. After a second labor strike the following year, many mines in the district reduced their workforce or completely shut down. Miners and their families began to move away, and by 1910, the population of Altman was one hundred.

Since the beginning, the American Eagle Mine dominated the region, and it still does to this day. The district's first millionaire, Winfield Scott Stratton, purchased the mine in 1895 and developed more mines next to it. Today, the remnants of those mines hold sentinel over the ghostly remains of Altman.

THE GHOST TOWN OF Midway was so named for its location between Cripple Creek and Victor. It was located at the base of Bull Hill within a quarter mile of Altman. The town filled the miners' needs somewhat after the demise of Altman. For the miners, the main attraction in Midway was the Grand View Saloon. Owners McKillip and Doyle named their establishment for the fabulous view of the rows of mountain peaks at such a high elevation.

Coal for the nearby mines was shipped to Midway, where as many as thirty rail cars of fuel transported to the mines daily. In 1901, the *Denver Times* noted, "Midway is rapidly forging to the front as a shipping point for ore."

Just west of Midway, at Squaw Gulch, was the "Glory Hole." It was the result of many planned cave-ins in an effort to gain access to the ore in the mountainside. One of the most colorful mines near Midway was the Wild Horse. It is said that the owner discovered it and named it in 1897 after his horse dragged him through a rich ore vein that had outcropped at the earth's surface. Over half a million dollars' worth of gold had been processed from the Wild Horse when the Woods brothers, founders of Victor, purchased the mine for a mere $35,000. Gas in the lower levels caused the mine's closure in 1903.

The mining town of Midway had its own band. *Mazzulla.*

This was the only saloon in Midway and was quite popular. *DPL.*

Midway never suffered the bad reputation other towns had and was always considered sort of a sleeper mining community. Perhaps the ghosts are sleeping as well. The weathered timbers of the false-front Grand View Saloon, where it was said that apparitions of miners appeared, were torn down by the Newmont Mining Company.

THERE WAS ONLY ONE company town in the Cripple Creek Mining District. Winfield, built in 1900, was the brainchild of Winfield Scott Stratton, owner of the fabulously wealthy Independence Mine, which made him the first millionaire in the district. Located approximately a half mile from Midway, Winfield was a lavish town, perhaps more to impress businessmen and investors than the miners. Nice, uniform red brick and white frame buildings with red roofs housed offices, kitchens, dining halls, boardinghouses and laundry services. There were no saloons or dance halls.

The miners who lived in Winfield worked at both Stratton mines, the Independence and the Martha Washington. The mines were profitable until after the turn of the century, when Stratton sold the Independence for $10 million. After that, mining slowed down, but the miners stayed. There was work to be had at the mines until 1980, when a gold-leaching company arrived. Many of the buildings were torn down to make way for the new operation.

Today, very little of the Winfield company town remains. A few cabins dot the hillside, and a mine head frame is the only reminder of what was once here. But if you listen closely, you can hear miners whistling in the wind.

This is all that is left of Stratton's company town of Winfield. *DPL.*

Elkton served the needs of the miners at the nearby Elkton Mine. *DPL.*

THE MINING CAMP OF Elkton was said to be home to one ghost, if not more. Following the publicized rich gold find by Bob Womack, thousands of miners flocked to the Cripple Creek Mining District. One such man was William Shemwell, a blacksmith from Colorado Springs. On a warm sunny day in the summer of 1891, Shemwell dug a hole near the head of Arequa Gulch, partway up Raven Hill. Within a few feet, the tenderfoot miner discovered a rich pocket of gold. When he filed his claim, Shemwell named it the Elkton, supposedly for two bleached-out elk antlers he saw nearby where he dug. Shemwell needed money to develop his mine. Back in Colorado Springs, two grocers, brothers George and Sam Bernard, grubstaked Shemwell for thirty-six dollars. In return, Shemwell agreed that the Bernard brothers would receive half of all Elkton profits. Within a year, the Elkton became profitable with just low-grade ore production. The Bernard brothers saw further potential and bought out Shemwell's half interest. For the next two years, the brothers poured all their money into developing the Elkton. Then one day, the nearly bankrupt mine owners struck another rich gold pocket. So many miners were hired that a small community below the mine was established, also named Elkton. Located approximately halfway between Victor and Cripple Creek, the business district did very well and included

multiple grocery stores, drugstores, saloons and barbershops. By 1900, the town of Elkton contained two hundred residents, and by 1904, it boasted a population of twenty-five hundred. Ore production from the Elkton Mine was averaging $16 million annually.

Meanwhile, the 1894 Cresson Mine, located above the Elkton, had been sitting idle for years. In 1910, Richard Roelofs, a geologist, built a tramway down Arequa Gulch. He was able to produce enough low-grade ore, which was hauled out by the tramway, to make the Cresson profitable. Soon, miners were hired, and more families settled in the town of Elkton. It was about 1910 that the town of Elkton reached its peak population of three thousand. At that time, the town included five hotels, a meat market, a mercantile and two saloons. As the town grew, it overtook smaller mining camps such as Arequa, Beacon Hill and Eclipse. In 1938, the mine was still producing and had a crew of one hundred miners.

On November 24, 1914, miners on the twelve level struck an enormous gold vein. Known as the Cresson Vug, the ore chamber was fifty feet high, twenty feet long and fifteen feet wide. The ore was so pure that Roelofs hired armed guards to travel with each ore shipment, as there was no need for reduction or milling. Miners who worked the vug area were handpicked by Roelofs and were required to change clothes at the end of each shift to prevent any chance of high-grading (stealing) ore. The first shipment of ore yielded $40,000. The following year, Cresson Mine produced $2 million in gold ore. In 1916, the Cresson Mine was sold to Cripple Creek millionaire Albert E. Carlton for $4 million.

By 1920, ore mining was less profitable. In the case of the Elkton and Cresson Mines, the lower levels became inaccessible due to water levels. In 1929, Carlton completed a large underground tunnel to drain the mines. The Carlton Tunnel proved successful, and soon the mines were producing again. Not long after the end of World War II, Carlton built his Carlton Mill, which was completed in 1951 and located just below the Elkton Mine. On opening day, Lowell Thomas conducted his radio broadcast live from the new mill. During the ceremony, it was Thomas who pushed the starter button for the one-thousand-ton capacity plant. In the first two years of operation, the Carlton Mill produced $4 million worth of gold bricks. When the Carlton Mill ceased operations on December 31, 1961, production at the Elkton Mine also stopped.

Today, not much of Elkton remains. The mine ruins and the mill are still visible. Rumors and whispers of ghosts in the region began in the early 1960s. Apparitions of miners with pickaxes have been reported near

the mines and on the streets of the abandoned town. Others claim they hear whispers within the rotting timbers of former homes. Or is it just the blowing wind?

> *The wild hurrah of the average mining camp is noticeably absent in Anaconda.*
> *—W.C. Calhoun, publisher of* History of Cripple Creek, *1896*

TODAY, THE FORMER MINING camp of Anaconda is nothing more than a few crumbling buildings down in the gulch. In its day, it was one of the more important gold camps in the Cripple Creek Mining District. The center of a violent labor dispute and later a victim of fire, Anaconda died a slow, sad death. Perhaps the reports of ghost sightings are of those who were caught up in the town violence or simply mourners longing for the days now long in the past.

Located halfway between Victor and Cripple Creek, Anaconda was incorporated in 1894. Supported by the miners of the rich Mary McKinney Mine, as well as the Anaconda Mine, within a year the town had spread to

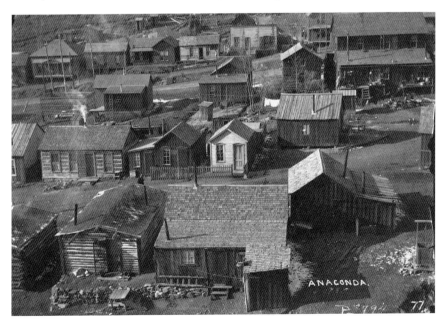

Anaconda was one of the largest and most popular mining towns in the region. *DPL.*

a half mile long at Squaw Gulch. In 1896, railroad millionaire David H. Moffat bought the Mary McKinney. By 1900, the population at Anaconda had swelled to just over two thousand. This was the peak era for the town. The main street was two blocks long and lined with stores, saloons, a church and a schoolhouse. All three regional railroads served the town. The *Cripple Creek Morning Times* of January 1, 1900, reported the following: "The activity of Anaconda and the crowded condition of the switches, attest the fullness of the city's claim of being the chief producer of the district. Her warrants are at par. Her people are out of debt. The class of homes is of the best—nice cottages, dotting the hills, on either side of the stream."

One of the newcomers to town was John Anderson, brother of Susan "Doc Susie" Anderson of Cripple Creek. John Anderson attained work as a miner at the Mary McKinney. In the spring of 1900, he contracted pneumonia. On March 16, 1900, twenty-five-year-old John Anderson died. Susan wrote the following in her diary, "John died at 6:15 p.m. Was so strange to think of John dead but he has suffered all a mortal can. We are happy he died unconscious of his pain."

Famed Roaring Twenties star Mary Louise Cecelia "Texas" Guinan began her career in Anaconda. A native of Texas, the eighteen-year-old dark-haired beauty arrived in 1902 for an extended visit with her sister Margaret and Margaret's husband, William Conley, a miner employed at the Mary McKinney Mine. Guinan attended Sunday morning Mass with her sister's family and soon began playing the church organ during the services. In this manner, she began crafting her stage presence. When she was not at church, Guinan could often be found playing the piano and entertaining the patrons in the local saloon. Guinan's two-year visit at Anaconda came to an end when an old beau, Johnny Moynahan, arrived from Denver. Moynahan, a cartoonist with the *Rocky Mountain News*, took Guinan back to Denver, where they were married on December 2, 1904. Within two years, the marriage had ended in divorce, and Guinan moved to New York City. It was there that she became a star, appearing on Broadway and in over three dozen films before her death in 1933.

On a November night in 1904, during the bloody labor war, fire broke out in the grocery store on the main street of Anaconda. With low water pressure, the fire could not be contained. By morning, nearly every building in Anaconda had burned to the ground. Despite the decline in ore production, the townsfolk were determined to rebuild, but very little was actually accomplished.

By 1909, many families had moved away, and the post office finally closed. Today, a few timbered homes remain below the piled tailings of the Mary McKinney Mine. Large timber barriers hold back the tailings from the highway below. Also visible is the foundation of the town jail. The Cripple Creek & Victor narrow-gauge railroad gives tourists rides that end at the site of Anaconda.

Of all the mining towns in Teller County, Anaconda is truly a ghost town. The modern mining company Newmont Mining has saved many of the mining headframes and relocated them away from its pit mining area, which has swallowed so much of Teller County's mining history.

CHAPTER 7

MORE GHOST TALES OF TELLER COUNTY

The mountain ranching community of Florissant was established in 1870 by Judge James Castello. It is still an active community today, and very little has changed, including the residents of the hereafter. When Castello brought his wife, Catherine, and three sons into the valley, they were the first white people to settle in the region. In that year of 1866, Castello built a large frame home for his family. In June 1870, Castello built a trading post near the junction of East Twin Creek and West Twin Creek, near the base of Fortification Hill. Castello purposely chose this location as it was next to the Ute summer camp of his friend Ouray. Castello did a brisk business with the Indians, and with Catherine's home cooking, the post became a stopping place for travelers as well. Castello established a post office in 1872, which he registered with the name Florissant, after a town in Missouri. Many travelers stopping at the Castello Trading Post traded tired or lame oxen and horses for needed goods. With his growing stock of animals, Castello established his own ranch.

Sadly, in 1878, Judge James Castello died in his home. His obituary, printed in the *Rocky Mountain News*, reads, in part, "The state of Colorado and especially his county, have lost a most worthy and useful citizen, and a wide circle of personal friends will mourn with his stricken family in their great bereavement." A few years later, Catherine Castello tragically died in the house when her dress caught fire.

Following the arrival of the Colorado Midland Railroad in 1887, the town built a depot and became a lumber supply station, particularly after the

The haunted ranch house and the barn where a woman hanged herself. *Celinda Reynolds Kaelin.*

gold discovery at Cripple Creek. Florissant prospered, and the population grew. Tragedy struck in 1907, when fire leveled nearly half of the business structures in the town. The January 17, 1907 issue of the *Gazette Telegraph* reported the incident:

> Fire early last evening destroyed half the business section of Florissant, 37 miles west of Colorado Springs on the Colorado Midland railroad. Nine buildings on the west side of Castello Street, the main street of the village, were burned to the ground, but the flames were stayed before they had caused further destruction. It was feared for a time that the entire town would be wiped out.

Fortunately, one of the buildings still remaining is the 1866 home of the Castellos. Today, it serves as the Castello Street Coffee House, where it is believed that the ghosts roaming the building are those of both Judge James Castello and his wife, Catherine. Staff members and patrons talk of lights turning off and on by themselves, rearranged furniture and cold spots in various rooms.

The vast lush meadows surrounding Florrisant are dotted with farms and ranches. Less than a mile west of town is Twin Creek Ranch, where the century-old Victorian house is said to be the host of at least one ghost, if not more.

In the late 1880s, the wife of the ranch owner gave birth to a stillborn child. Not long after, the wife hanged herself in the barn. It is said on windy nights her cries can be heard. Nevertheless, the Victorian-era ranch house stood quiet for nearly a century. Sometime during the mid-1960s, a murder occurred in the house. Since then, the victim has been said to haunt various rooms of the home.

It is said that a quarrel between two men resulted in a gunfight. Both men fired, but only one man fell. The owner of the home wrapped his victim, who was still alive, in an old blanket and hauled the man down the stairs to the basement. There, he dug a shallow grave in the earthen floor and buried his victim. And there he laid, in secret silence—or so everyone thought.

Over the next few decades, rumors of ghostly happenings at the ranch house abounded, but no one ever took them seriously. Then, in the 1980s, the owners of the ranch house, Harold and Celinda Kaelin, reported hearing noises during the night, and various items would be found moved in the morning. It is said a strange male voice could be heard but not understood on the first floor of the house, and the rooms on the second floor were so cold in spots a person could see his breath. The Kaelins tried to communicate with their ghostly guest, but to no avail. However, the couple's children had better luck. The ghost apparently told the children that he was the gunshot victim and was buried alive in the basement. Because of his religious beliefs, he could not "cross over" because he had not received the last rites. After the children told their parents of the ghost's plight, an exorcism of sorts was conducted, and it was thought that the ghost had crossed over. Or had it? Rumors still abound that the Teller County ranch house is haunted. I have been a guest at Twin Creek Ranch many times. While I have never experienced anything supernatural, I have seen the bullet hole on the stairway—proof that a shooting did indeed occur in the Victorian ranch house.

Just south of the haunted ranch house is an equally haunted house on Crystal Peak Road. The haunting of this home is quite contrary to the other ghost stories thus far, as this house was built in 1980. Nevertheless, eerie things have happened to the many owners since its construction.

It is believed that the land was originally that of a goat ranch in the mid-1800s, and the particular house site was where the goat rancher's cabin was. It is further thought that a hand-dug water well, typical for the time, would have been very near the cabin. Just up the road from the site is Fortification Hill. This is where the Ute Indians built a fort of adobe and rock with a high lookout port for protection against their enemies. A special section in the *Gazette Telegraph* of March 1936 included a story about the Ute fort. Reporter C.S. Dudley wrote:

> *Early settlers reported that there was a wall around the east and northern slope of Fortification Hill part way up from the bottom. It was a dry wall of rocks, piled one upon another. Charles Fry, a pioneer farmer of the Divide-Florissant region, who came there in 1890, says he remembers this wall; that in fact, he hauled some of the rocks in it away, to be used for bridge abutments. Some of this rock also probably went into buildings in Florissant.*

The unusual modern house near Florissant has two floors and a basement. The tight curving stairway leads to the second floor, where there are small rooms with slanted ceilings and tiny windows. It is said that furniture moves in these rooms. But it is the basement that seems to be the haunted hangout of the supernatural. Paranormal investigators with Light in the Dark Paranormal were filming while at the house. Broadcast on an episode of *Better Ghosts and Gardens*, the finished basement was in the process of being torn up. The center of one room was completely dug out. The owner of the house at the time, Dan Piotrowski, claimed an apparition told him there was a hidden water well beneath the house. Could this be the original well dug by the goat rancher? The investigating team used its EVP equipment, which eventually recorded an unknown entity saying "drain the well" and "underground." Could this be a portal by which a ghost cannot escape? Who is the ghost? Being near the Utes' fortress, the property could have once been the scene of a Ute battleground. Is the ghost a Ute or Ute enemy caught between there and the afterlife? There are no answers. The haunting continued.

Eventually, Piotrowski and his family moved out of the house and used it as a rental property. The renters never stayed longer than a few months, and the property went into foreclosure. A new owner bought the haunted house in 2012 only to sell it in short order. Since then, there have been three additional owners. Apparently, the unknown ghost is still in residence.

Woodland Park, at the summit of Ute Pass, is the largest town in Teller County today. It is also said to be quite haunted.

Daniel Steffa, a local rancher, saw the opportunity to become quite wealthy when the Colorado Midland Railroad began building in the region in 1887. Steffa quickly platted his pastureland for a town and named it Manitou Park, despite the fact that most settlers and travelers along the Ute Pass Wagon Road knew the region as Summit Park. In 1890, the Woodland Park Town Improvement Company was formed to address the water shortage. Within a year, it was able to complete a pipeline to a nearby reservoir. When the town incorporated later that year, the citizens chose the name Woodland Park. One of Colorado's first historians, Frank Hall, wrote the following in his 1891 *History of Colorado*:

> *Woodland Park is situated on a high broad plateau 8,484 feet above sea level, and has a protected and sheltered situation. It affords a fine view of Pikes Peak, and near by are Iron and Sulphur Springs, almost hidden by native shrubbery and wild flowers. During the past year a hotel and several cottages and stores have been erected, as well as a church and school. Here is also a good-sized lake.*

Curiously, given the future town hauntings, one of the first items of business the town fathers did was to pass a decency and morals ordinance. Gambling and prostitution were banned within the city limits, as was public drunkenness. A steep $100 fine was levied for those who violated the ordinance. Ironically, thirty years later, Woodland Park allowed speakeasies and gambling and tolerated illegal liquor during Prohibition.

The Ute Pass Wagon Road became the main street of commerce for Woodland Park. Hotels, restaurants, a variety of stores and doctor, lawyer and real estate offices lined both sides of the dirt street. No fewer than five sawmills were in business in and around the area, providing an abundance of lumber for railroad ties as well as Colorado ore mines and, later, mountain tunnels. There was such a high demand for the lumber that it was a common sight to see lumber stacked in high piles awaiting shipment to various locales. The extreme abundance of timber eventually led to the formation of the Pike Forest Preserve, one of the first in the country. It was later renamed the Pike National Forest.

Today, the same main street of commerce is U.S. Highway 24. The popular Ute Inn Bar and Grill in Woodland Park is purported to host ghostly guests. It is said that the original owner, Albert Berdstrum, roams the

building at night, and footsteps can often be heard on the back stairway. The ice machine is said to turn on and off on its own, and the women's bathroom locks on its own. There are cold spots throughout the bar, and staff members report smelling perfume when no one else is in the room.

Just north of Woodland Park, in the Pike National Forest, is Saylor Park. The park was established in 1970 as an area for survival training for the United States Air Force Academy. Cadets train for skiing and snowshoeing in the winter and hiking and endurance training in the summer. Cadets going through the survival training at Saylor Park have experienced seeing moving lights near granite monoliths in the early morning hours just before dawn and have also reported seeing apparitions moving through the trees.

Approximately eight miles north of Saylor Park, along Trout Creek on Highway 67, is Rainbow Falls Park, situated on the border of Teller and Douglas Counties. The surrounding area has been the scene of several murders over many decades. If there were ever a scary spot for specters to hang out, this would be the place.

Two hundred years ago, the Ute Indians spent the summer seasons camped in this region, where they hunted and gathered fruits for the winter months. The focal point of the park, Rainbow Falls, drops four hundred gallons of water per minute. The Big Cold Spring attracted French fur trappers in the 1820s. This spring is cold year-round but never freezes, staying a constant fifty-one degrees. Evidence of both the Utes' and the trappers' time in the park can be seen in the limestone cave above the spring. Heavy black soot from fires has stained the cave ceiling.

In 1861, the first white man settled in the area, a French trapper by the name of Bergen. In 1882, H.G. Thornton acquired the land adjacent to the Big Cold Spring. Here he built a fish hatchery, the first in the state, to raise rainbow trout. Within a few years, Thornton's trout were favorites on restaurant menus from Colorado Springs to Denver. For the next few decades, Rainbow Falls Park went through a series of owners but always remained open to the public, as it does today.

For whatever reason, the area near, in and around Rainbow Falls Park has attracted murderers. The first recorded murder occurred in 1868. The victim was found in the cave above Rainbow Falls. The murder was never solved. On June 15, 1993, a hiker found the partially clad and decomposing body of a young female just off U.S. Highway 67 in

an otherwise abandoned campsite at the Rainbow Falls Campground. Investigators believe the body had been there two to three days. That happened to be the time frame of a motorcycle rally held in the vicinity. The deceased girl, between sixteen and nineteen years of age, was dressed only in a short-sleeve motorcycle T-shirt. The murder was never solved, nor was the identity of the teenager. In July 2005, a camping trip among friends ended in murder. Two separate groups of young men were camped at Rainbow Falls Park. Both groups began partying in the evening, one celebrating a birthday. In the early morning hours of Saturday, July 18, one group assaulted the members of the other group, resulting in one dead and two injured. Three young men, ages eighteen to twenty-two, were arrested for murder, assault and auto theft.

Rainbow Falls Park remains open to the public with several campsites, fishing and hiking. However, some have maintained that the area is haunted. Could it be the victims of those unsolved murders?

A FEW MILES EAST of Woodland Park is Rampart Range Road. The road climbs to 9,460 feet at Bald Mountain, and a branch, Road 312, ends at the Woodland Park Ranger Station north of town. Over the years, there have been deaths and even murder on this road. There are also many tales of creepy happenings.

Apparently, the road holds strange and scarey memories for several individuals. Beth Rayer-Davis wrote:

> *When you go up Rampart from Woodland Park, you can go left or right. In between the two roads on the mountainside, you can see a light. I was told to never go up the right side if the light was on. The south side road was always the scariest, where the lone standing chimney was, and the white house where I did see satanic stuff inside along with coagulated blood.*

Speaking of the white house, Chris Tate related:

> *Do you remember the white house that was on Rampart* [Road]*? The house that burned down. The first snow that winter, it snowed everywhere but inside the outline of that house that burned down. The haunted house. Did the devil worshiping thing in there and whatever else they did in there. But yeah, it was a freaky place.*

Joe Mowen also remembered the white house:

The creepy white house close to the intersection where Rampart Road splits off has some memories. It's about .5 miles after the right turn and off to the right. It's been demolished now, but lots of parties there in the 1980s at this abandoned house. There was one incident around 1983 when myself and then girlfriend Susan F. hid behind it with the deep woods behind. We were going to scare the next partygoers. Then a huge crashing sound came from the silent forest behind us. She ran left, I ran right. We told the story then went back to City Market (where I worked during high school) and recruited about twenty of us and searched the hillside. We found an old cabin down the mountain with a totem pole. A couple of us [fell] in the creek [rocky gorge] while running. All around you could hear dogs or what we thought were wolves.

Chris Chambers grew up in the region and wrote:

Growing up in Woodland Park, there were always urban legends surrounding Rampart Range Road. A few facts include that it is a high place to find human remains, including the missing Heather Dawn Church's remains; that was a big deal at the time. When people go missing, it is probably a good place to begin your search. In addition to this, I have heard everything from stories about Crazy Eddie chasing you at night with his chainsaw, the mysterious vacant lot with cross signs painted at the entrance where a witch used to live and snow does not stick to the ground. Of course, they sold this lot and a new house has been built now. I wonder if they are living in an American horror story type situation?

Harry Lyons agrees with Chambers's assessment of the scary rocky road. He remembered the following:

There is an old rumor in town that back in the '70s or '80s there was a group of people that lived off of Rampart Range Road that worshiped the devil. They were known by many locals to perform satanic rituals. The rumor says that at one point five to ten kids in town showed up missing, never to be found again. The local authorities "hush-hushed" the situation, and there is no record of any children ever missing. When I asked a well-known local historian, he did confirm the story that there was a house where a group of people lived that were known in the area to be "devil

worshipers." He remembered the people well and said that while they were living on Rampart Range Road, several people in town made complaints that their animals showed up missing. According to the local historian, people in town thought the missing animals were used in some sort of satanic sacrifice by the group of crazy folks that lived up on Rampart Range Road just outside of town. The historian denied ever hearing about an incident involving missing children.

On September 17, 1991, thirteen-year-old Heather Dawn Church was kidnapped from her home in Black Forest, near Colorado Springs. Following her disappearance, more than thirty officers spent a week searching the area around the Church house. They found nothing. El Paso County sheriff's deputies, FBI agents and a large group of volunteers spent two years looking for Heather. The Friends of Heather Dawn Church Foundation was formed by several residents in October 1991 to keep the case in the public eye. Then, in the fall of 1993, a hiker discovered a human skull near an old rusty car just off Rampart Range Road. A few days later, El Paso and Teller County officials found human bones, including a jawbone. The next day, Friday, September 17, 1993, exactly two years after the disappearance, dental records were utilized to identify the remains as those of Heather Dawn Church.

Becky Sample told of her experience on the eerie road:

At the top of the road to the right towards the reservoir was an old lodge called Timber Ridge. My husband and brothers lived there in the early 1970s. Haunted! Behind the lodge was a place called the Cat House. It was a house of prostitution back in the early 1900s. All burned down now. The fox farm is gone, but the fireplace is still standing. Timber Ridge was a club for gambling and drinking back in the day. There are homes behind a locked gate at that location now.

Tiffany Gille recalled finding a skull on the road:

When I was about twelve, I went raspberry picking up on Rampart Range. My friend and I were walking around and found a circle of stones with crosses and some sort of animal skull in the middle of it. [It] looked like a sacrificial altar. There was melted candles too. Nothing happened because we ran away. But I have heard so many stories about human and animal sacrifice up there. I think Heather Dawn Church's body was also found up there.

Chris Wyatt remembered an eerie sight on the road:

> I was four wheeling around and came to a campsite. There were a bunch, I'd say maybe twenty, of stick figure dolls made out of twigs and sticks all hanging by their necks on branches all over the area on the trees. We didn't stick around for too long. Only weird thing I've seen up there.

The high, windy mountain dirt road lends itself to frequent car accidents. One victim related his strange experience:

> One time when I was in high school, a group of friends and I took my small car down Rampart [Range] Road. We got to a rough part on the road, and it felt like something tried to push my car off the road. My car was full [of passengers], and we had a car full of friends following us. Once my car almost slid off the cliff, the car behind us flashed me to pull over. When we got out, everyone in both cars turned on me and were angry that I "almost killed everyone in my car!" I could see by the look in their eye that they suddenly all wanted me dead. Another friend then pulled up to the situation, and things suddenly changed and everyone's instant rage to murder me ceased. My friend said that as he pulled up to the heated situation, he saw two dark shadows float away from all of us and noticed everyone's attitude instantly change. My friend told me all of this later and thought that for some reason demon spirits possessed everyone I was with to turn on me all at once. But when he showed up, the evil spirits possessing my friends left.

Another gentleman who did not want to give his name related:

> In high school, I was up there [on Rampart Range Road] with Leanna, and we had the dome light on in Leanna's car, and someone scratched my window. Leanna called me a liar because she didn't hear anything. Then I was in the same spot with Jeremiah and the exact same thing happened. This time, Jeremiah heard it too, and we were scared shitless, so we took off! My brother has a story about sacrificed animals where that burnt-down house was and if it snows the snow never sticks to the ground there. Then I heard of a guy named "Crazy Pete," and he wanted to kill everyone out there. I already told my daughter about it and that I never want her to go up there. I'm never going to go up there again. They found Heather Dawn Church's body up there, that missing girl that used to be on all the

posters when we were kids. And then, one time I was left up there alone and I had to walk down in the middle of the night. One of the worst nights of my life. I think there's evil out there. And another thing is about my friend Lucas. Our mutual friend at a sleepover tried to cast rune stone spells on us, then Lucas's remains were found up on Rampart surrounded by rune stones. It could have been the brother; we don't really know. But it was his wife casting rune stone spells.

Car accidents were not the only mechanical mishaps in the Rampart Range Road region. Jack Slaughter recalled a plane crash in the area:

Awhile back, there was a plane wreck on Rampart [Range] Road when the air force was doing an experimental flight and ran into some poor weather. I can't remember whether the pilots died or not, but the remains of the plane are still up on Rampart due to it being too difficult to get to the area to remove the debris. One time I went hiking around the area with some friends looking for the plane crash site. We did not find the plane debris that time, but while back in the woods miles off the road, we stumbled upon a fifty-gallon barrel filled half the way up with dark black liquid. We didn't continue to inspect it!

Just a few miles southeast of Woodland Park is the small community of Crystola. It's hard to imagine this pristine area was once rife with violence. It is one of several reasons why locals claim it is haunted. In 1860, a family by the name of Benedict established a ranch in the area that they named Trout Park. For over a decade, the Benedicts built their cattle empire on land that had never been filed for legally. Nevertheless, when other families, such as the Scotts and the Sharrocks, tried to settle in the region, Benedict did whatever he thought was needed in an effort to run them out. Case in point, in 1870, Benedict set fire to George Sharrock's ranch house. Undaunted, Sharrock rebuilt, and Benedict burned that house down as well. When Sharrock rebuilt for the third time, Benedict finally left him alone. By 1873, Sharrock had built a fourth building, as it was listed on the Hayden Survey reports that year. Sharrock had established his "Junction House," a roadhouse serving travelers passing through the region. Later, the Scott family operated a portion of their ranch house as a boardinghouse.

In 1878, Henry Clay Childs, former Speaker of the U.S. House of Representatives, and his wife, Catherine, settled in Trout Park. It was the Victorian era of Spiritualism, and the Childs couple were heavy involved.

Apparently, they were not alone, as soon fortunetellers and psychics from all over the valley came to "visit" with the Childses. Spiritual sessions with crystal balls, séances and fortunetelling lasted into the wee morning hours. During one of these sessions, it was prophesied that rich deposits of gold would be found near the Childses' ranch. To that end, local spiritualists, including Henry Childs, formed the Brotherhood Gold Mining and Milling Company in 1897. The company brochure read as follows: "The prospector is saved the trouble of locating a mine by an accommodating wizard who, instead of locating the future bonanza for himself will locate it for anybody who will put up a sufficiency of cash in advance."

It was due to the spiritualists' founding of such an enterprise, which brought more settlers to the area, that the town was renamed Crystola in 1899. For the next ten years, the town flourished with a grocery store, post office and mercantile store and hotel. The Colorado Midland Railroad brought a constant stream of spiritualists and self-proclaimed psychics to the town. Yet for all the prophesying and crystal ball predictions, gold was never discovered at Crystola.

Following the death of Catherine, Henry Childs became a recluse and hopeless alcoholic. When he died in 1910, he left instructions in his will that his two-thousand-acre estate at Crystola was to be transformed into a school for Spiritualism. The March 17, 1911 issue of the *Gazette Telegraph*

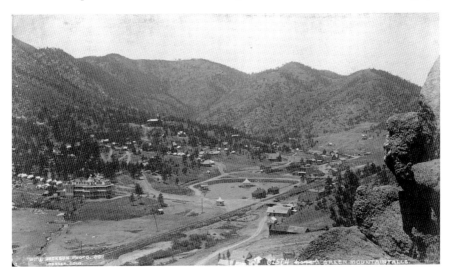

Don't let picturesque Green Mountain Falls fool you; it is said to be haunted. *DPL.*

reported the opening of the Childs University of Psychic Research. Noting the school's emphasis regarding the study of the supernatural, the paper opined that "ghosts, goblins and spirits from the unknown are presumed to walk the hills in the region of Crystola."

Today, very little is left of Crystola. Most of the buildings burned in the 1940s. The town grocery, the Crystola Inn, was replaced in 1945 by the Crystola Roadhouse. Rumors are still whispered of ghosts and goblins wandering the streets of the town founded on the supernatural.

LOCATED ON THE BORDER of Teller and El Paso Counties, the pretty little settlement of Green Mountain Falls belies the supernatural entities said to inhabit the area.

In 1881, George Howard, of Buena Vista, saw the lush green meadowland for the first time. Before the summer was over, Howard had sold his ranch at Buena Vista and paid $600 for good ranchland in the region. Howard later named the area Green Mountain Falls for all the beautiful waterfalls in the surrounding area. Howard partnered with an English real estate developer, W.J. Foster. The idea was to establish a ritzy summer resort. To that end, the Green Mountain Falls Town and Improvement Company was formed in 1887. By the following summer, excavation for a lake, by means of horse-drawn plows, had been completed. When it had been filled, a small island was left in the middle of the lake where a gazebo was built. The charming effects of the lake setting accomplished what the town company had set out to do. Soon, homes were being built and businesses were established in Green Mountain Falls.

In 1888, town developer W.G. Riddock erected one hundred tents near the resort area, something the *Mountain Falls Echo* newspaper called the "Cloth Castle Camp." A year later, the newspaper reported on the new Green Mountain Falls Hotel:

> There are seventy guest rooms, parlor room and dining room that featured a good cook [with] *few dishes but well selected, and a sideboard to get his toddy. You don't see the continual changing of dresses here that is so tiresome to many ladies; they sit on the broad veranda with their sewing or book, while the husband reads, plays cards, smokes his pipe and enjoys the same comfort as if at home. The children are as little care as if they were at school, roaming over the hills as free as birds.*

The town of Green Mountain Falls was incorporated in 1890 with a seven-member board, including J.H. Jewett as mayor. That first year, the city budget was $500, which included such expenses as streets, bridges, ditches, elections and "contingent expenses." It didn't take long—just seventeen days—for the city council to realize there wasn't enough money and impose a $1 tax on male dogs and a $2 tax on female dogs. It seems as if the town was in financial straits from the beginning, but Mayor Jewett soon found a way to fill the city coffers.

Following the great gold strike at Cripple Creek, the mayor and some members of the city council found a way to capitalize on the nearby mining boom and gain a bit of favorable media press.

"Gold has been found at Green Mountain Falls and quite a book has started in the Green Mtn. Falls Company's stock." This dazzling headline appeared in the *Colorado Springs Gazette* on January 27, 1892. The *Gazette* article continued, "It is reported that on the company's lands there has been discovered quite a large bit of gold-bearing gravel and some placer claims have been staked off on the adjoining property."

The February 6, 1892 issue of the same paper again lauded the gold findings: "Another rough assay of Green Mtn. Falls ore made yesterday showed a value greater than that of the night before, being nearly $800.00."

Was the reporter sensing a scam or a whimsical pipe dream, as his next article, dated February 19, 1892, stated:

> *The promoters of the Green Mtn. Falls mining district have exhibited great moderation and self-control. Their mining claims only extend north to Monument, east to Colorado Springs, south to Fountain, and west to Florissant! Their discretion is all the more remarkable...in the fact there is nothing whatever to lead us to believe that there is a reasonable chance of finding gold anywhere within the limits of the district.*

On February 28, 1892, the reporter wrote: "The tunnel on the Green Mtn. Falls property is now 23' in solid granite...and said to be favorable to finding gold on the inside."

The April 19, 1892 issue ran an article stating, in part, "Mining operations at Green Mtn. Falls continue to be active. From Mayor Jewett's tunnel, an assay of 13 ounces yielding $9.00 was obtained." Was it a scam by local promoters or a dream of the community? No gold worth mining was ever located near, in or around Green Mountain Falls. In fact, a great deal of money was lost by the many miners who flocked to the area, believing otherwise.

As with most scandals, the community recovered and eventually became the settlement it was intended to be. Today, bed-and-breakfast establishments have replaced the hotel. Several generations of original settlers still live in Green Mountain Falls. Along with stories of long ago are tales of hauntings in the town, apparitions seen in the trees and howling in the rocky hillsides at night. Some locals claim they have seen Bigfoot in the hills as well.

Teller County is indeed a ghostly place to visit. You never know what or who you may encounter.

CHAPTER 8
PHANTOMS OF UTE PASS

Ute Pass, approximately eight miles east of Florissant, is not only one of Colorado's most historic mountain trails but is also haunted with tales of bloody murder and Ute spiritualism.

Named for the Ute Indians who discovered the pass over two hundred years ago, the trail was a main thoroughfare to the rich gold fields in the 1890s and today is a scenic byway. The Ute Indians guarded their trail exceptionally well. Rock and red adobe forts were erected at various strategic points along the passage to thwart any intrusion by their enemies. These circular forts were approximately chest-high and could accommodate no more than four braves. Irving Howbert, who arrived in Colorado City in 1859, fought the Indians in his younger years. In his memoirs regarding the Ute Indians, Howbert wrote:

> *Every year, as far back as history or tradition goes, as soon as spring opened and grass was abundant, large parties from different tribes of the plains came marching in, and, after making their usual offerings at the "Boiling Springs," (Manitou) continued on up through Ute Pass into the mountains. There the Utes usually were waiting for them, whereupon a succession of battles between the contending tribes would take place, with success generally on the side of the Utes, who were the better fighters.*

After improvements to the trail were made in 1860, the Colorado City newspaper, the *Rocky Mountain Herald*, reported: "The new free road lately

completed from this city to the Park, Blue and Snowy Range Diggings is the choicest, the finest, the most level, and the best constructed for horse, carriage or heavy wagon travel that there is in the country."

The new Ute Pass Wagon Road climbed 3,000 feet to its summit at Summit Park (now Woodland Park) at 9,165 feet above sea level. Through the canyon portion, it was quite narrow and hugged the dark canyon cliff walls. Because of the canyon walls and winding terrain, the pass was dark and forbidding, except at midday, when the sun was directly overhead. Nevertheless, traffic was quite heavy along the road, so much so that westbound travelers were allowed out of Colorado City only until noon every day. Then, from noon to dusk, eastbound travelers used the road.

In 1863, the bloody Espinosa brothers, Felipe and Vivian, were terrorizing settlers in the South Park region of Colorado Territory. In March, the Espinosas moved northeast, where they killed their third and fourth victims on Ute Pass. The bodies of two unidentified men were found near the stage stop on March 16, 1863. The *Rocky Mountain News* reported the incident, as related by Fremont County sheriff Egbert Bradley, in the March 19, 1863 issue: "The sheriff and his deputy started in pursuit, following the killers (from Fremont County) to Colorado City and on up through Ute Pass, and were the first to find two men the bandits had murdered at the stage stand up Ute Pass the morning after they had murdered Harkens and returned to Colorado City and reported those murders."

The Espinosas' reign of terror finally ended when scoutsman Tom Tobin captured them and brought their severed heads to the governor for proof and payment.

Ten years later, a series of murders and mysterious disappearances occurred on Ute Pass. In 1873, a six-horse Concord stage carrying an unknown number of passengers as well as forty dollars' worth of gold is said to have traveled the pass from the east side but never made its destination. A thorough search of the area yielded nothing. It's as if the stagecoach disappeared without a trace. Then, in 1877, Mr. J.T. Schlessinger, personal secretary to General William Jackson Palmer, rode up the pass but never rode out. A few weeks later, his body was found on a pull-off on the pass. An examination of the body revealed a bullet had been shot through his heart.

In 1886, one of the most brutal, unsolved murders in Colorado history occurred near the base of Ute Pass. On a warm summer evening, neighbors found an older woman by the name of Kearney in the barn of her small

ranch. Her head had been split open by an axe. The horribly mutilated body of her six-year-old grandson was found in a nearby grain bin. The kitchen table was set for three places, the third person unknown. A $500 reward was posted for information leading to the murderer, but the case was never solved. The remains of Kearney and her grandson were buried in the Colorado Springs Pauper Cemetery, which was then located at today's Twenty-First Street and Lower Gold Camp Road.

By 1884, several railroad companies were competing for business in the mining towns of Aspen and Leadville. The Ute Pass Wagon Road had been a major thoroughfare for wagon freighters to Leadville ever since gold was discovered in Oro City. However, no railroad company had tried to build through Ute Pass, partially due to the constant reminder of the many deaths that had occurred on the pass. An editorial in the April 25, 1884 issue of the *Colorado Springs Daily Gazette* took issue with the blight on the Ute Pass reputation, stating:

> *The Denver papers, in the interests of Canon City, satirically or ironically, but certainly untruthfully, refer to as the "terrors" of the Ute Pass Road. The untruthfulness of the assertions of the newspapers which have characterized the Ute Pass Road as dangerous and the longest route to the scene of the late gold excitement. By the route we traversed, which is certainly the best one for any railway point into the exploded mining section, the distance is forty-six miles from Colorado Springs.*

Despite the efforts of the local newspaper editorials, the Ute Pass Road continued to be unnoticed by the railroad companies yet remained viable for the settlers, ranchers and businesses in the southwest country of Pikes Peak. One of those businesses was lumbering. With the expanding westward population, lumber was in high demand, and it was actually the lumber industry at Summit Park (Woodland Park) that revitalized the Ute Pass Road. In 1888, the Colorado Midland Railway built tracks through the pass and on to the mines of Aspen, Leadville and eventually Cripple Creek. When completed, the railroad line included thirteen tunnels and several trestles to navigate the steep grade of the pass.

In 1895, the newly acquired railway, then known as the Midland Terminal Railway, traveled west over Ute Pass to Divide and then southwest toward the gold camp. The fifty-five-mile trip to Cripple Creek took two hours, with a ticket price of two dollars. At the height of the railroad company's success, four passenger trains made the trip twice each day. The Cripple Creek Flyer

even provided sleeper cars. The Midland also provided freight cars for ore shipments to the processing mills at Colorado Springs. Often, armed guards accompanied these shipments.

There were also disasters and tragedies over the years. During a blizzard in 1899, a train derailed, and forty-nine passengers were killed. A few days later, an avalanche closed a large portion of the rails for nearly a month.

Because there were so many accidents in the dark, deep, winding tunnels, the railroad conductors quickly dubbed them the "deadly thirteen." Case in point: on February 14, 1922, one of the worst, not to mention most unusual, railroad accidents in the state's history occurred on Ute Pass. During the bitter cold early morning hours of that day, several head of cattle belonging to Thomas Wales, a Cripple Creek rancher, had found their way to the shelter of tunnel #4, not far from Cripple Creek. A few hours after sunrise, a Midland Terminal train sped into the dark tunnel. The train hit five of the cows and emerged from the tunnel with blood and guts covering the entire front section. The reporter for the *Colorado Springs Gazette Telegraph* dubbed the incident the "1922 Valentine's Day Massacre."

When the Carlton Mill was built in 1949, there was no longer a need to ship ore out of the mining district. Within a year, the Midland Terminal Railroad had ceased operations through the canyon. By the following year, railroad workers had removed the rails.

Today, there are five tunnels that remain along the ridge of the original rail bed, located approximately three miles south of Cascade. Ghost hunters and paranormal investigators have been exploring these tunnels for years.

> *We saw the glowing red ball of light float by the old Widow Maker tunnel. We knew right away that we were having an experience that was purely supernatural.*

The Widow Maker tunnel is the largest of the tunnels on the ridge. Inside the dark, dank hole in the mountainside are a slew of bats that have made it their hangout. The legend of this particular tunnel is that it is haunted by the ghost of a man who escaped from an insane asylum. There may be some truth to the legend, as a man by the name of Michael Ryan, a railroad engineer, was once a patient in an insane asylum in Minnesota. In any case, in 1895, Ryan sustained a severe head injury during a railroad accident near Cripple Creek. No longer able to perform his railroad duties, Ryan filed a grievance with the company and received a rather large settlement.

By 1900, Ryan was a homeless man living in a shack very near the entrance to tunnel #4, known as the "Widow Maker" tunnel. The few people who had homes in this area kept their distance from the mountain hermit but would often see him on the road, always carrying a railroad lantern. Over the next few years, Ryan became a curiosity in the region, so much so that the *Gazette Telegraph* ran articles such as the following on December 11, 1904. Under the headline "Queer Life of Hermit Who Says He Knew Jay Gould," the article read:

> *Living alone, in a tumbled down shack, in the mouth of tunnel number 4, near the iron spring, Michael Ryan, an aged hermit, is a mystery to the neighborhood. Ryan talks at times to persons with whom he has become acquainted, but his conversation drifts to Wall street [sic] the stock pits of Chicago and New York, and he speaks with familiarity about his old friend, Jay Gould. His talk would indicate a relationship with such men as Schwab and Morgan. The hermit is highly educated in Latin, and speaks German, French, Italian and English, fluently. He will not beg, although he lives in squalor and cooks his meals in an old iron kettle outdoors. Whether demented or not no one seems to know, but he will often climb a tree and bark like a squirrel and when tired out, returns to his shack and goes to sleep upon a bed of leaves and torn blankets.*

A year later, the *Gazette Telegraph* of February 2, 1905, reported that its favorite hermit, Michael Ryan, was missing. The article read as follows: "Manitou's entire police force has joined in the regional search for the hermit, Ryan. Children, who are out of school on holiday signed up to join the search with concerned neighbors, who fear the mentally ill old man might freeze to death in the sub zero weather."

Apparently, the mentally deranged man returned or was eventually found. The *Gazette Telegraph* attempted to interview the recluse and published the following report in its April 25, 1905 issue regarding the endeavor:

> *Hermit Resented Intrusion with Bucketful of Water*
> *Professor M.C. Gile of Colorado College and Mr. Barry Were Greeted by a Shower of Stones by the Recluse*
> *Michael Ryan, the queer old character, who is familiarly known as the hermit, has at last come to grief. It all happened yesterday afternoon. Professor M.C. Gile, of Colorado College, and Mr. Barry, a paymaster for General Palmer, were starting up the hill when without warning, the old*

hermit ran out of his cabin, which is near the Midland Railroad trestle and at the foot of the trail. He evidently objected to them being so close to his abode, and though they had in no way molested him he wave preliminaries and doused Mr. Berry [sic], who was in the lead, with a pan full of water he was carrying. Not satisfied with this, he struck Mr. Barry with a heavy blow on the wrist with the pan.

Then he began throwing a fusillade of rocks upon the mountain climbers. Seeing that the the old man was not in a playful mood, they beat a retreat. Reaching a telephone they endeavored to call the police, but failing to locate the stalwart guardian of the law, who was absent in Colorado Springs, they notified the sheriff's office. Ryan did not look with favor upon the deputy sheriff, and neither was he awed by the display of the silver star on the sheriff's vest.

He barricaded the door and it was only after a lively scuffle, that he was amendable to reason. The old hermit was not placed in custody today, but will be examined by county officials tomorrow, to ascertain his sanity. It

Ute Pass was first used by Ute Indians, hence the name. *DPL*.

A pack train traverses the Ute Pass wagon road. *DPL*.

> *seems that he has been in the habit of greeting wayfarers in this manner for some time, but this was the first time a formal complaint has been lodged against him.*

Following an examination and appearance before the county board of health, it was deemed that Michael Ryan was indeed insane. He was transported to the Woodcraft Work Asylum in Pueblo, Colorado. Within six months, Ryan had managed to escape the institution.

Then, in 1923, scattered human remains were discovered deep inside the Widow Maker tunnel. By the decomposition, it was determined that the person had died some months earlier. Near the largest set of remains was a

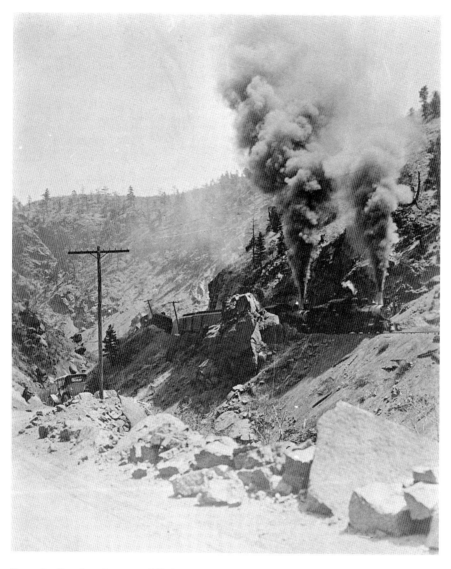

Several railroad workers were killed or injured while building the rails through the canyon. Even a tunnel was named for the many deaths. The Widow Maker tunnel is said to be haunted. *DPL*.

shattered railroad lantern. Authorities and several locals determined that the remains were those of Michael Ryan. The remains were hastily buried inside the tunnel, and the whole matter was hoped to have been forgotten. Not so.

It is said that flashes of light seen from the tunnel are signals from none other than the ghost of railroad engineer Michael Ryan.

In 1920, a group of concerned citizens spent considerable time placing markers along the original Ute Pass created by the Ute Indians.

Today, U.S. Highway 24 runs through Ute Pass. The otherwise scenic drive is often disrupted by unexpected wisps of fog, even on crystal clear days. At night, strange colored lights emerge, not unlike orbs.

BIBLIOGRAPHY

Primary Sources

Anaconda Gold Mining Company stock ledger, 1892–99. Company controlled by banker David H. Moffat. Cripple Creek District Museum.

Colorado WPA Writers' Program, 1936–42. "Superstitions; the Supernatural; Ghost Stories." Colorado College, Cripple Creek Ledgers. Included in this work are the Cripple Creek Sewerage Company records from 1902 to 1904.

Cripple Creek Directories, maps and mining records. Cripple Creek District Museum.

El Paso County Abstract ledgers, 1891–96.

El Paso County Court Records, Colorado Springs, Colorado.

Interviews and Correspondence

Charlotte Bumgarner
Charles Frizzell
Harold and Celinda Kaelin
Dorothy Mackin
Steve Mackin
Michelle Rozell
Erik Swanson

Bibliography

Richard Tremayne
Stephanie Waters
Glen Wilson

Archives and Additional Sources

Colorado History Center
Cripple Creek District Museum
Denver Public Library, Western History Department
Pioneer Museum, Colorado Springs, Colorado
Tutt Library, Colorado College, Colorado Springs, Colorado

Newspapers

The various newspapers accessed for this work are noted in the text along with exact quotes. Newspaper articles accessed during research include:

Bell, Tanya. "Ghosts, Gamblers Are Attracted to New Inn." *Colorado Springs Gazette-Telegraph*, January 25, 1997, D1.
Chambers, Charles. "Legends of Rampart Range Road." *News of Woodland Park*, November 14, 2016.
Colorado Springs Gazette-Telegraph, February 6, 1995.
Mountain Jackpot (Colorado Springs, CO), October 28, 2008.

Books

Aldrich, John K. *Ghosts of Teller County*. N.p.: Centennial Graphics, 1986.
———. *My Favorite Ghosts*. N.p.: Centennial Graphics, 1988.
Asfar, Dan. *Ghost Stories of Colorado*. N.p.: Ghost House Publishing, 2006.
Brown, Robert L. *Ghost Towns of the Colorado Rockies*. Caldwell, ID: Caxton Press, 1982.
Clifton, Chas. S. *Ghost Tales of Cripple Creek*. N.p. Little London Press, 1983.
Cornell, Virginia. *Doc Susie*. New York: Ballantine Books, 1991.
Dallas, Sandra. *Colorado Ghost Towns and Mining Camps*. Norman: University of Oklahoma Press, 1985.

Bibliography

Drake, Raymond L., and Bill Grimstad. *The Last Gold Rush*. N.p.: Pollux Press, 1983.

Eberhart, Perry. *Guide to the Colorado Ghost Towns and Mining Camps*. Thousand Oaks, CA: Sage Books, 1959.

Feitz, Leland. *Cripple Creek!* N.p.: Little London Press, 1967.

———. *Cripple Creek Railroads*. N.p.: Little London Press, 1968.

———. *Ghost Towns of the Cripple Creek District*. N.p.: Little London Press, 1974.

———. *A Quick History of Victor: Colorado's City of Mines*. N.p.: Little London Press, 1969.

Friggens, Myriam. *Tales, Trails and Tommyknockers*. N.p.: Johnson Books, 1979.

Goodman, Linda. *Love Poems*. N.p.: Taplinger Publishing, 1980.

———. *Love Signs*. N.p.: Taplinger Publishing, 1978.

———. *Star Signs*. N.p.: Taplinger Publishing, 1987.

Greenway, John. *Folklore of the Great West*. Sanger, CA: American West Publishing, 1969.

Hauck, William. *Haunted Places: The National Directory*. New York: Penguin Books, 2002.

Howbert, Irving, Inez Hunt and Wanetta Draper. *Ghost Trails to Ghost Towns*. Thousand Oaks, CA: Sage Books, 1958.

Kaelin, Celinda Reynolds. *Pikes Peak Back Country*. Caldwell, ID: Caxton Press, 1999.

Levine, Brian. *Cities Gold: Victor, Cripple Creek Mining District*. N.p.: Century One Press, 1981.

———. *Cripple Creek: City of Influence*. Cripple Creek, CO: Cripple Creek Historic Preservation Department, 1994.

———. *Cripple Creek: Victor Mining District*. N.p.: Century One Press, 1987.

Martin, MaryJoy. *Ghosts, Ghouls and Goblins of Colorado Twilight Dwellers*. Boulder, CO: Pruett Publishing, 1985.

Mazulla, Fred M. *Cripple Creek: The Fist 100 Years*. Denver, CO: A.B. Hirschfeld Press, 1956.

Pettit, Jan. *Ute Pass: A Quick History*. N.p.: Little London Press, 1979.

Price, Charles F. *Season of Terror: The Espinosas in Central Colorado, March–October 1863*. Boulder: University Press of Colorado, 2013.

Spell, Leslie Doyle. *Forgotten Men of Cripple Creek*. N.p.: Big Mountain Press, 1959.

Sprague, Marshall. *The King of Cripple Creek*. Colorado Springs, CO: Friends of the Pikes Peak Library District, 1994.

———. *Money Mountain.* N.p.: Bison Books, 1953.
Waters, Frank. *Midas of the Rockies.* Thousand Oaks, CA: Sage/Swallow Press, 1939.
Williams, Lester L. *Cripple Creek Conflagrations: The Great Fires of 1896 that Burned Cripple Creek, Colorado.* N.p.: Filter Press, 1994.
Wolfe, Doris. *The Gold Camp Road: The Short Line to Cripple Creek and Victor.* N.p.: self-published, 1988.
Wolle, Muriel Sibell. *Stampede to Timberline.* Thousand Oaks, CA: Sage Books, 1949.
Wommack, Linda. *Colorado's Landmark Hotels.* N.p.: Filter Press, 2012.
———. *From the Grave: A Roadside Guide to Colorado's Pioneer Cemeteries.* Caldwell, ID: Caxton Press, 1998.
———. *Our Ladies of the Tenderloin.* Caldwell, ID: Caxton Press, 2005.

Journals, Periodicals, Pamphlets and Magazines

Keske, Maralyn S. "Residents of Mt. Pisgah Cemetery, Cripple Creek, Colorado 1892–1988." Self-published.
———. "Residents of Sunnyside Cemetery, Victor, Colorado and Fourmile Cemetery, Fourmile Community, Co: 1875–1988." Self-published, 1989.
McMechen, Edgar C. "The Founding of Cripple Creek." *Colorado Magazine,* January 1935.
Victor Chamber of Commerce. "Victor Gold Rush Days." July 1983.
Wommack, Linda. "Bob Womack: A Common Cowpoke Discovers Gold." *True West Magazine,* August 1992.
———. "Of Pipe Dreams & Scam Artists: Green Mountain Falls." *Ute Pass Vacation Guide,* Summer 2006.
———. "There Had to Be Gold." *Cripple Creek Colorado Commemorative Centennial Program,* City of Cripple Creek, 1991.

Television Channels and Programs

The History Channel
The Travel Channel
Unsolved Mysteries

About the Author

A Colorado native, Linda Wommack is a Colorado historian and historical consultant. She has written nine books on Colorado history, including *Ann Bassett: Colorado's Cattle Queen*; *Murder in the Mile High City*; *Colorado's Landmark Hotels*; *From the Grave: Colorado's Pioneer Cemeteries*; *Our Ladies of the Tenderloin: Colorado's Legends in Lace*; *Colorado History for Kids*; and *Colorado's Historic Mansions and Castles*. She has also contributed to two anthologies concerning Western Americana.

Linda has been a contributing editor for *True West* magazine since 1995. She has also been a staff writer, contributing a monthly article for *Wild West* magazine, since 2004. She has also written for the *Tombstone Epitaph*, the nation's oldest continuously published newspaper, since 1993. Linda also writes for several publications throughout her state.

Linda's research has been used in several documentary accounts for the national Wild West History Association, historical treatises of the Sand Creek Massacre and critical historic aspects for the Outlaws and Lawmen Jail Museum in Cripple Creek, Colorado, which opened in 2007.

Linda feeds her passion for history with activities in many local, state and national preservation projects; participating in historical venues, including speaking engagements; hosting tours; and being involved in historical reenactments across the state.

About the Author

As a longtime member of the national Western Writers of America, she has served as a judge for the acclaimed national Spur Awards in Western Americana literature for eight years. She is a member of both the state and national Cemetery Preservation Associations, the Gilpin County Historical Society, the national Wild West History Association and an honorary lifetime member of the Pikes Peak Heritage Society. As a member of Women Writing the West (WWW), Linda has organized quarterly meetings for the Colorado members of WWW for the past ten years, served on the 2014 WWW Convention Steering Committee and currently is serving her third term as a WWW board member.

Visit us at
www.historypress.com